P9-DWX-553

WATERCOLOR
WORKBOOK

Bud Biggs and Lois Marshall
WATERCOLOR WORKBOOK

NORTH
LIGHT
BOOKS

To Maggie

Sweetheart, Wife, Mother,
Bookkeeper, Accountant,
Chauffeur, Cook, Bountiful
Helper, Gracious Lady.

Published by NORTH LIGHT BOOKS, an imprint of
F&W Publications, Inc., 1507 Dana Avenue,
Cincinnati, Ohio 45207.

Copyright © 1978 by Fletcher Art Services, Inc.
all rights reserved.

No part of this publication may be reproduced
or used in any form or by any means—graphic,
electronic, or mechanical, including photocopying,
recording, taping, or information storage and
retrieval systems—without written permission
of the publisher.

Manufactured in U.S.A.
First paperback printing 1987

95 94 93 7 6 5

Library of Congress Cataloging in Publication Data

Biggs, Bud.
 Watercolor Workbook.

 1. Water-color painting—Technique. I. Marshall, Lois,
1913- joint author. II. Title.
ND2430 B53 751.4'22 79-12299
ISBN 0-89134-203-6

Edited by Fritz Henning
Designed by David Robbins

Contents

A Word to my Readers

My greatest pleasure is watching the students in my classes grow and gain expertise in their watercolor painting. Through following the steps outlined in this book, you will become one of my students. I shall try to teach you how to take your brush in hand and put your watercolor on paper so you will paint a better picture. I shall give you a critique on your work by asking you questions about your painting. Your mistakes will no doubt be the same ones students in my classes make. Their problems are the basis of my questions. By self criticism you will achieve skill and independence. It is your awareness that I want to develop, a sharpened capacity of observation. An honest critique of your own work will help you acquire perceptual skill, understanding, and imaginative know-how.

This is a workbook. It is not to be read and put aside. You must read it again and again, and you must practice. There are no tricks. No miracles! If you do not make mistakes, you will not grow. Your work will be better the second time than it was the first. The better you get, the worse you will think you are, until you take out your first picture and see how far you have come.

Subject matter changes, so each painting is a new challenge, but the principles are the same. You will study design. Guidelines, not rules! Inspiration is not a sudden light from space but a compulsion born of sharpened observation and perception.

Important Beginnings
—The Plan of the Book

Design exists in everything around us from the simplest blade of grass to the most complex human structure. To design is to have a purpose. Designing is deliberate, purposive planning and consists of arranging the elements of art to create a unified, pleasing effect.

What is an element?

In chemistry, an element is the simplest, basic unit of a substance. Gold is an element. It can not be broken down to a simpler form. You can melt it, hammer it, crush it, or combine it with other substances, but it will always be gold. A design element is the simplest, basic unit. In every work of art, some or all of the elements of design exist, and the way in which they are used and combined helps to determine the quality of the work. These elements, the basic building blocks of design, are listed below:

COLOR
VALUE
SPACE
SHAPE
FORM
LINE
TEXTURE

These basic things are all you have with which to design a picture. And no matter how complicated a good design may be, you can always find these elements.

Watercolor is a live, vibrating medium with a will of its own. But as exciting as watercolor may be, the only way you can create a good design is to use the above basic elements common to all art.

These design elements are the subject of this book. Difficult though it is to deal with only one or two at a time, without others intruding, the first part of the workbook presents the design elements followed by several lessons in the watercolor use of each. Critiques will be included for your growth and development. The second part of the workbook contains some completed pictures in which design elements are combined according to certain principles, including movement, contrast, emphasis, and unity.

Part One

Elements
of Design
Color &
Value

Transparent Color

Transparency is the splendid quality of letting the light shine through.

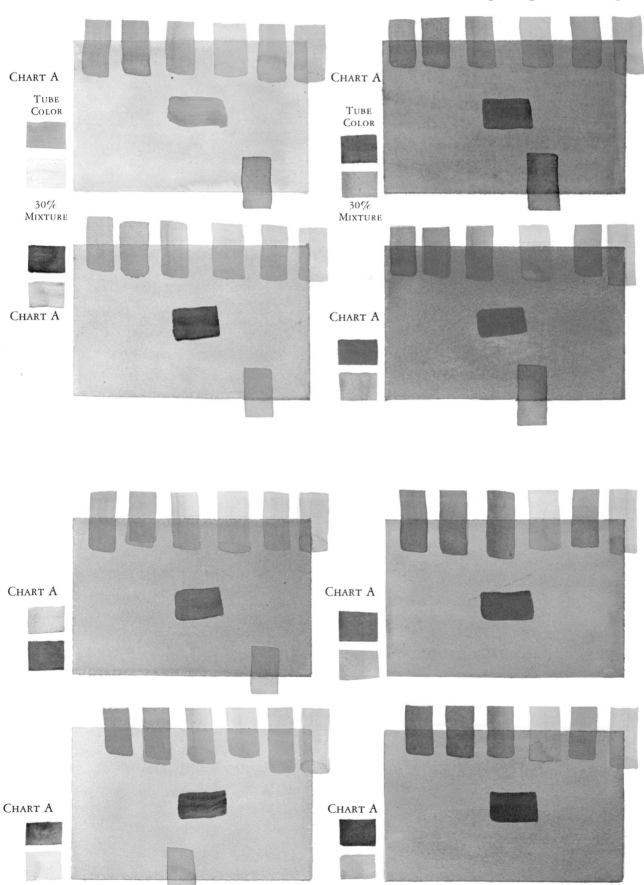

Chart A

Tube Color

30% Mixture

Chart A

Chart A

Tube Color

30% Mixture

Chart A

Chart A

Chart A

Chart A

Chart A

Color is both the visible fact and the miracle of light. Transparency is the quality of being lighted from within. Watercolor pigment lets the light shine through where it is reflected by the paper. This unique quality of transparency is the essence of magnificent watercolor paintings.

Hue is the name given to colors as contrasted with black, white, or gray. There are three primary colors, red, yellow, and blue, and they are located equidistant on a circle called a color wheel. If all three of these colors are mixed together, the result is a gray. But any two can be mixed to form one of the secondary colors. Red and blue make purple, and it should be placed equidistant between the two on the color wheel. Red and yellow will mix to make orange, and blue and yellow will make green. The secondary hue directly across the color wheel from the primary color is the complement. Complementary colors activate one another when used side by side, but when mixed together, the complement grays the color. The red tones seem warm, and the blues and greens, cool, but whether a color in a picture is warm or cool actually depends on the hues next to it.

The best watercolors available come in tubes, and they may be bought in many colors. However, you need not buy a lot of different colors because tube pigments can be mixed to gain new colors with effective subtle changes and variations. There are many ways of mixing watercolors. When you mix two wet watercolor pigments on a palette, you get a third color. When you mix wet pigment with wet pigment on a piece of watercolor paper, the colors run and blend and create many charming variations. Because of the singular quality of watercolor to be transparent, when one color is painted on top of another dry transparent watercolor pigment, the light shines through both colors to create yet other values and hues. In the lessons ahead, you will use all the above methods of achieving variations in mixing pigments, but in this first lesson, the experiment deals with transparent color painted over dry transparent pigment. Look at the illustration at the beginning of this lesson. Note the colors in Charts A to the left of the large rectangles and study the difference between the tube color and the thirty percent mixture.

Using enough water to dilute the pigment to about thirty percent of the tube color, mix up a large pool of green. Using the same process, mix additional pools of

Lesson 1

each of the following: Burnt Sienna, Ultramarine Blue, Alizarin Crimson, Indian Yellow, Antwerp Blue, New Gamboge, Cadmium Red Scarlet. You now have eight pools of liquid pigment, each stirred well and of a different color. Paint rectangles about three by four inches, making each a different color, leaving space between.

When the eight rectangles are completely dry, fill your brush from the green pool of color, stirring it well. At the edge of the green rectangle, paint a small shape about one inch long, half covering the large rectangle and half extending beyond. Now you have a new free value that cannot be mixed because it consists of looking through two transparent colors. Using the same technique, paint a small shape of the green mixture at the edge of each large rectangle. Note how the green over green becomes a darker green and the green over yellow becomes an exciting yellow green. Study each value and enjoy the beautiful colors.

Now, wash your brush, stir up the Burnt Sienna, and paint a shape over each of the rectangles, just as you did with the green. Using each color in turn, paint shapes about the edge of the large rectangles.

You used only eight colors. You now have almost a hundred. More colors can be achieved by repeating the process and painting another hue over each of the small shapes. In addition, one rectangle can be placed over another and rotated to achieve a thousand or more different colors.

All these hues are far more than you can ever use in a single picture, but with this technique and this knowledge you can create exciting color combinations. Most of the time you will paint with a limited palette. That is, you will choose three or five colors to use in a given picture. Perhaps you will select three warms and two cools. But think of the hues and values you can create from just five colors, and they will all be related. Not only will there be many colors and values, but they will be directly affected by the colors around them. Deliberately choose your palette for each picture. Try out the liquid colors on a separate sheet before you begin. Try a group of rectangles of your chosen colors. A limited palette makes for a harmonious picture because the colors are related.

Critique

Put up your picture of rectangles and sit back where you can study it from a little distance.

Is your watercolor transparent? Does it shine and glow? If not, was it because you did not stir your pigment mixture before you used it? Stirring your pigment is very important.

If your colors are dull and opaque, maybe it is because you used too much pigment. Look down into a full cup of coffee. When you look through about two inches, it looks dark and black. Put a drop on a piece of white paper and it looks light. Now be honest! Is your pigment about a thirty percent mixture as used in the illustration? Or is it near the tube color? The completed picture will be about a sixty-five percent value of the tube color. Don't try to go the whole way to the dark with just one stroke. Build it up with transparent washes.

You have just experimented with the hues that are created by the transparent color painted over dry transparent pigment. Now, try mixing some of the colors together on your palette. Note how they blend into a third hue that is different from the color on your chart. Also try mixing wet pigment with wet pigment on watercolor paper. Do not mix them with the brush, just make them liquid and overlap the edges. Watch the colors blend and run. Try all these methods of creating color. Which do you like best?

Watercolor is creative. The more experience you have, the more you realize the great importance of value change. This lesson is so simple, you may be tempted to say, "I don't have to do this exercise. I can see the color change."

This practice is probably one of the most important experiences you will have in the entire study of this workbook. You must actually experience the thirty percent mixture and the colors achieved. Learn by trial and error. Knowledge alone will not make you a watercolorist. Knowledge and practice together might!

Using Transparent Color

Many people can draw a tree.
Can you design one?

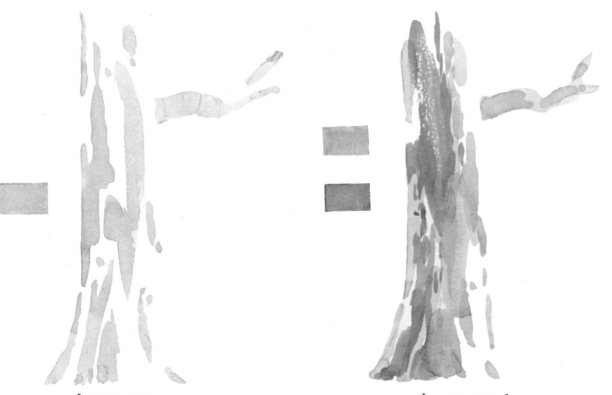

ILLUSTRATION 1

ILLUSTRATION 3

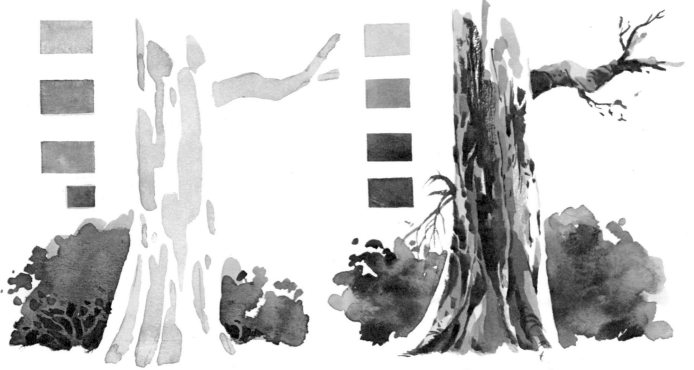

ILLUSTRATION 2

ILLUSTRATION 4

Now, you will use what you just learned in the last lesson about transparent color and design a tree. First select a limited palette, Antwerp Blue, Raw Sienna, Sepia, and Burnt Sienna.

Study Illustration 1 at the beginning of this lesson. Use about a thirty percent mixture of Antwerp Blue. There is no drawing. Simply paint interesting shapes which denote a trunk. But beware! This process is not as simple as it seems. There are no two shapes alike. They are not the same size. The spaces left unpainted between the blue shapes are not alike in size or outline. Now of course, this brings up two other elements of design, shape and space. You will study these in a later lesson. For the present, it is enough to concentrate on variety. Note that the limb on the right does not connect with the blue line. There is a space. Oh, the importance of space! Without looking any more at the example and without actually trying to copy, design the blue and let it dry. Blue recedes, and, in this case, is the color farthest back.

In Illustration 2, you will note that at no place do the green bushes touch the blue trunk. Therefore, the green can be painted immediately, even before the blue is dry. See how the yellow extends above the green? Begin by painting varied shapes of Raw Sienna on both sides of the trunk. Make the trunk bigger by leaving a space between the bushes and the blue. Let it dry. Mix a good green from Raw Sienna and Antwerp Blue. Using the transparent green on top of the yellow, make a new shape. Be careful! Do not follow the first outline. Don't get excited and cover all the yellow. It is best always to leave some of the original color showing. Leave a yellow highlight on top. While it is wet, drop in some jewels. *Jewels* are bright colors dropped into the wet pigment. Use Cadmium Yellow. Just drop in a bit here and there at the top of the green and let it explode.

When it is dry, use some of the same green and make branches and twigs at the bottom of your bushes. You do this by painting shapes, and leaving the branches and trunks. You will study this procedure more in a later lesson, but for right now, try. I call this process, painting behind. You are painting behind the branches, as it were, and they show because the green over green makes a darker value and lighter green looks as if it were out in front. This effect gives you the feeling of being able to see far back into the bushes.

Lesson 2

While your painting dries, study Illustration 3 found in the beginning of this lesson. Using about a thirty percent mixture of Burnt Sienna make a variety of warm shapes on the trunk. Keep your watercolor juicy and transparent. Note that you do this just as you did the rectangle in the first lesson. Some of the color overlaps the blue, some extends beyond. Do not cover all the white. Study the illustration carefully for subtle colors and challenging shapes. Put the workbook aside and paint your own spatial forms. Think while you work! Leave some white and blue showing.

Study Illustration 4 carefully. Here are well-placed, well-shaped darks. See how the darks "pop" when placed next to the light? Use some blue in the Burnt Sienna to make a dark value. Note how the warm color vibrates when placed next to a cool. And especially notice that you do not cover all the white or colors. The darks are not scattered all over the picture. In making the branch, it should be dark as it comes next to the tree, but notice also the white. The branch is darker at every other turn to show it is twisting toward and away from the light. The darks must be exciting with no two shapes alike.

Quickie

Try the exercise of the four trees in Illustration 5 on the opposite page. Note the following things carefully before you begin.

Trees have a way of dividing space. Look at the variety of area left for good design.

Trees occupy space on the ground. One tree will stand in front and another at the side or behind the first. Study the Plot Plan in Chart A and look again at Illustration 5.

Finally, understand the use of colors by studying Illustration 6. The blue recedes, so blue is used in the trees that are behind the warm trees in the foreground. The trees are not the same color.

Design and paint your group of trees using the same process described in the beginning of this lesson.

Critique

Remember that the purpose of the critique is to help you become independent. It is to teach you how to see better. Spend time on each critique in the book. Be honest. Ask the questions. Give yourself honest feedback. It doesn't really hurt to talk a little out loud, even if you are by yourself.

Put your tree picture up and sit back and look at it. Get a cup of coffee, put your feet up, and be as objective as possible.

Did you outline either side of the tree? This is a "no, no." Study the examples again.

Did you cover all your pretty colors underneath, or can you see interesting shapes of blue, Burnt Sienna, and white, and a combination of these colors as they overlap?

Are your shapes alike? They should be different. Look at the white, unpainted areas. Are they varied?

Is your painting transparent? Was your pigment so heavy you have opaque colors? You should have stirred your color well. Your white paper should shine through the color to make it glow.

Place the workbook example beside your tree. Do you feel satisfied? If not, try again while it is fresh on your mind. You will do better next time. *Think* while you paint.

The picture is your partner. It will give you feedback. You can move color around and add to it. Look into your color on paper, and it will suggest to you varied forms.

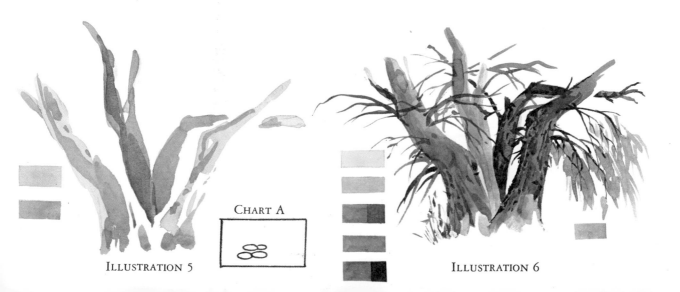

CHART A

ILLUSTRATION 5

ILLUSTRATION 6

The Importance of Values

*The success or failure of a picture may well
depend on the relationship of values.*

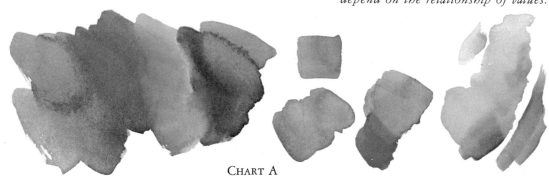

CHART A

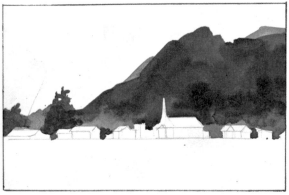

ILLUSTRATION 1

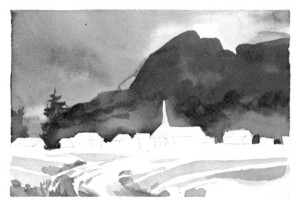

ILLUSTRATION 3

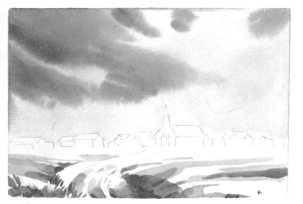

ILLUSTRATION 2

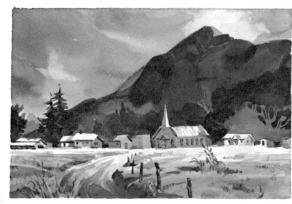

ILLUSTRATION 4

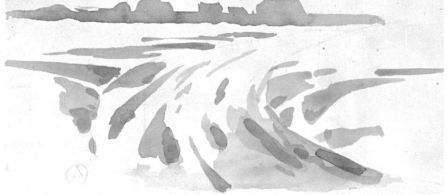

CHART B

Value is the relative lightness or darkness of a color. The essential word in that statement is *relative*. It is the relationship of one part of the picture to another with respect to lightness and darkness, intensity or dullness. There is no such thing as a dark value or a light value by itself. You have to ask, "Dark, compared to what? Light, compared to what?" A value is directly affected by the color that surrounds it. A single value that in one picture may be light, in another picture, may be dark. Between the darkest and lightest values of a picture are countless values, limited only by the artist's imagination. Shapes close in value tend to merge, like the distant mountains and the sky. Values that contrast too greatly are glaring and flashy.

Instead of painting pigment over dry color, in this lesson, we shall mix wet pigment on paper creating many values and colors. Practice first on a separate piece of paper. Study the color swatches (A) at the top of the opposite page. The limited palette will be Ultramarine Blue, Alizarin Crimson, Indian Yellow, Green, Cadmium Scarlet and Payne's Gray. Make about a forty-five percent mixture of Ultramarine Blue on your palette and stir well. Keep your pigment liquid and juicy and paint an area of your paper with the blue. Wash your brush and fill it with Alizarin Crimson. Now paint an area alongside the blue and overlap the edges. The process of painting one wet color over another to create a third or even a fourth color I call *interlocking colors*. Try it with other colors. Interlock a little yellow into the blue. Repeat with the green. Look at the new colors and values you've produced! If your colors did not run and blend, they were not liquid enough, or not sufficiently stirred. If they look washed out when they are dry, you did not use enough pigment.

Paint Illustration 1. Begin by sketching some small houses and a church in the bottom third or fourth of a half sheet of watercolor paper. Your buildings need not look like the ones in the illustration, but they should be small, well grouped, varied in shape, interlocking, and interesting in design. That is all you need to draw.

Mix ample pools of each color in your limited palette. Make sure each is liquid pigment and a deep, rich value. Concentrating on shape, make an interesting mountain top with the blue. In shaping your mountain look at the space you are leaving. Do not bring the blue too far down

Lesson 3

toward the house tops. Wash your brush and fill it from the crimson pool and interlock the colors and let them blend and mix on paper. Move the color around and borrow from it while it is still wet. You may drop in some jewels. Remember, jewels are brilliant colors dropped into the wet pigment for excitement. Drop in some Cadmium Scarlet. Do not try to keep the colors separate. Use ample pigment so the colors flow into each other without the help of a brush. Let the colors work for you.

Wash your brush and fill it with the green. With a flat brush and deep color, cut out the houses and church, leaving them white. Cut clean as if you were using a knife blade. Push the green color up into the colors just above. Be careful in blending the alizarin and green, or you will get an ugly, neutral color. Drop in a jewel or two of Cadmium Yellow into the green. Make the trees between the foot of the mountain and edge of the left side of the picture look far away by using a lighter value of blue and fuzzy edges. Do not make these trees alike. When the paint on the mountain is somewhat dry, but not too dry, paint some fir trees, projecting up behind the houses. Do not overdo it. Make an illusion of trees, label just one or two of the trees to spell out the rest. Leave something for the imagination of the viewer.

While this dries, study Illustration 2. You will do some area wetting. With a sponge or a clean brush, wet the sky beside the mountain and ground. Using Payne's Gray and Indian Yellow (mixed toward the yellow) paint action with clouds moving in. The yellow should overlap into the mountain so there will not be an edge.

Now paint in the foreground and road area. Study enlarged section (B) shown on page 18. Note how the ground does not go straight across the bottom of picture, but slopes in uneven forms towards the road. These shapes are called contour lines and will be studied in detail later. When you have painted the sky and ground your picture should look like Illustration 3.

Study Illustration 4. Some very transparent color has been painted on the houses and some well-placed darks in the front of the picture. Many artists feel they have to paint little background houses opaque with heavy pigment so the paint will not run. Usually this is not necessary if you keep in mind liquid paint will not run unless it touches a wet area. Complete your picture.

Critique

Sit back and view your picture with a critic's eye.

Did your horizon divide your picture in half? It is best to avoid dividing a picture in equal parts of any type, either horizontally, vertically, or diagonally.

Are the buildings varied shapes? Are they grouped well? Make sure they are not evenly spaced.

Is the color on the mountain the most beautiful color you have ever seen? Are the colors clear and bright? Did they happen to make mud? Are they transparent or opaque? You may need more practice in interlocking colors.

Is the road solid? Is it outlined? If so, it is wrong, and you need to study the examples again and practice some more. Does it have interesting color shapes and interesting unpainted spaces? Is the road white at the back, as it should be? There is also a white, soft area left unpainted at the bottom of the buildings. In the sky the light source is stronger than the colors. This area is very important. Did you achieve it?

Does the ground go parallel with the bottom of the page, or are there contour lines?

Do the trees make varied forms back of the houses?

Is there value change in the mountain? Is there also value change in the sky, or is it flat? Do the tops of the trees in the background follow the contour of the mountain? They should make an entirely new shape.

Now that you have given yourself an honest critique, look at your picture and list the things you have learned. Below are a few of the things that may be on your list.

> The meaning and importance of values
> Interlocking colors
> Roads, how to make them and how to leave them white at the back.
> Interlocking shapes of such things as buildings, mountains, trees, and sky.
> The importance of the white space left between the buildings and the ground.

Learn these lessons well. They apply to pictures everywhere, not just to this one painting.

Understanding Values

*A picture without adequate values is like
a library without books*

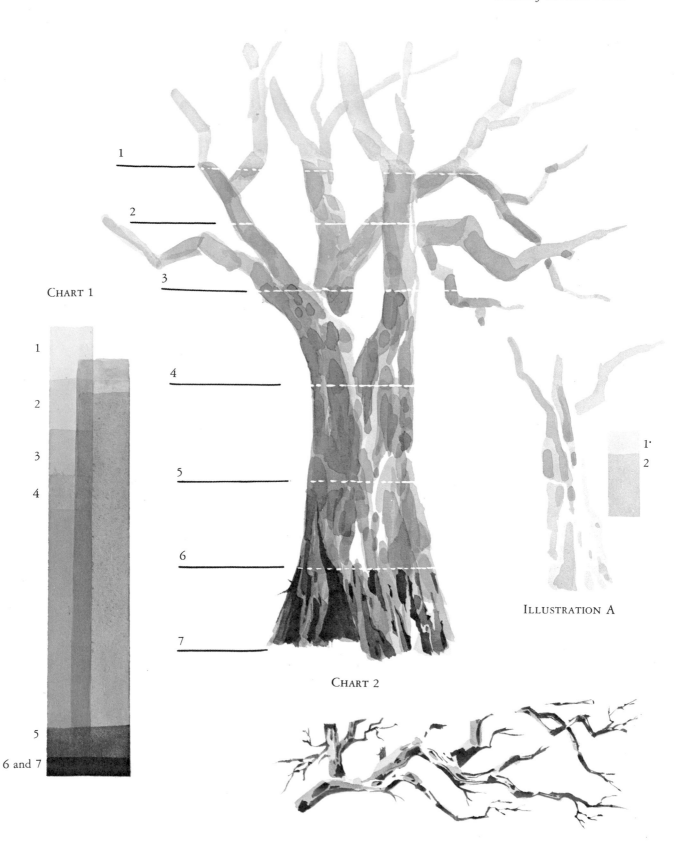

CHART 1

1
2
3
4
5
6 and 7

CHART 2

1
2
3
4
5
6
7

ILLUSTRATION A

1·
2

The middle values harmonize the picture into a single melody. The lights and darks sing out when placed side by side in the center of interest. It is the relationship of values you must come to understand.

You designed a tree in lesson two. By using this familiar design again, you can devote your attention to values. Use one cool and one warm color, Antwerp Blue and Raw Sienna. Two colors, but many values! Use two small jars as on page 24. Mix a thirty percent solution of Antwerp Blue in one jar and a thirty percent solution of Raw Sienna in the other. Keep this stirred well. You will use only the liquid in these jars for this practice. How do you get the darker blue? Ah, that's the secret. When you paint the blue mixture over some of the blue that has been allowed to dry, you get the darker, transparent value.

Before you begin, study vertical Chart 1. The first blue, numbered 1, is the blue from your bottle; 2, is the second application of the same blue over dry pigment. The rest of the chart shows how the blue deepens as additional washes are applied. Notice how the Raw Sienna strip overlaps the blue down the center. The Raw Sienna is the same thirty percent mixture, but it becomes a darker value when it is applied over the varied values of blue. Numbers 6 and 7 are Raw Sienna and a deeper value of Antwerp Blue mixed on the palette.

Study also Chart 2. The limbs at the top of the tree show the first application of blue, number 2 indicates the second application, and so on down the tree to values 6 and 7. Review these two charts until you thoroughly understand values.

Follow the suggested procedure step by step, applying your mixtures to dry paper. Start with your bottle of the thirty percent Antwerp Blue mixture. Without any preliminary drawing, paint a tree trunk and limbs as in Illustration A. Leave plenty of white. When this is dry, using the same mixture create the second value by making interesting shapes in the center and to the left, painting over some of your first blue. Do not cover up all your original shapes. Where a branch turns, make a deeper value. Remember, you do not go to your palette for more blue, you simply build up from your jar mixture, each time, letting the paint dry before you apply the next coat.

Lesson 4

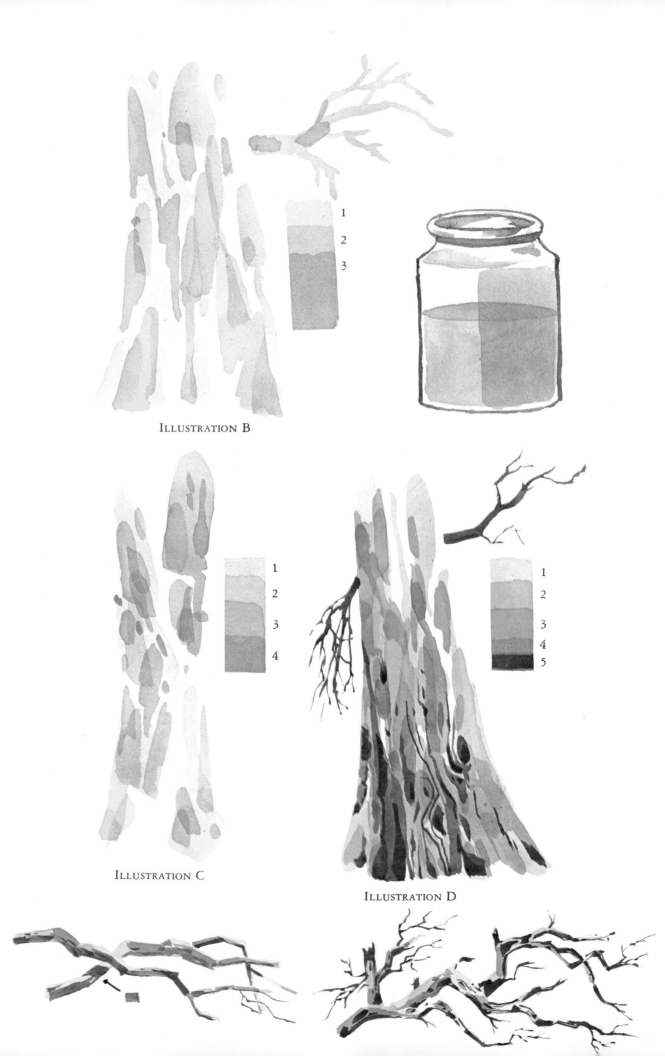

ILLUSTRATION B

ILLUSTRATION C

ILLUSTRATION D

Paint the third and fourth steps as seen in Illustrations B and C. This application comes chiefly in the trunk. Do not cover all your white or original blue.

At this point you are ready to use some Raw Sienna from the jar mixture as in Illustration D. Notice that some of the warm Raw Sienna covers white for one value; some covers a portion of each of the washes, creating different values. Pause for a minute and think what has happened. You used only two colors, but you have on your tree many additional values. In the first lesson on transparent colors, you started with only a few colors. By painting one transparent color over another dry pigment, you created many different colors. In this lesson you used only one color and created many values. Then, by adding only one more color to these values, you created additional values and colors.

You are now ready to do what you really wanted to do first, add the emphasis and the detail. Mix the 6 and 7 color and do your own thing.

Many students are impatient. They want to slap color on and go dark immediately. It is this build-up of values throughout your picture that makes for beauty. Subtle changes are exciting.

Do you like your tree? Can you almost feel the value changes making the tree turn and glisten? If not, then you have missed the point. Try again. This approach of value build-up is the secret of the pictures you shall paint as you improve and paint better pictures. Using this method, you always have control of your picture. By painting light, you can always come in and go darker. Dark first creates confusion. You are through. You can't move and you become frustrated.

Warm Against Cool, Cool Against Warm

If you want something to stand out,
paint it cool in a warm area,
or warm in cool surroundings.

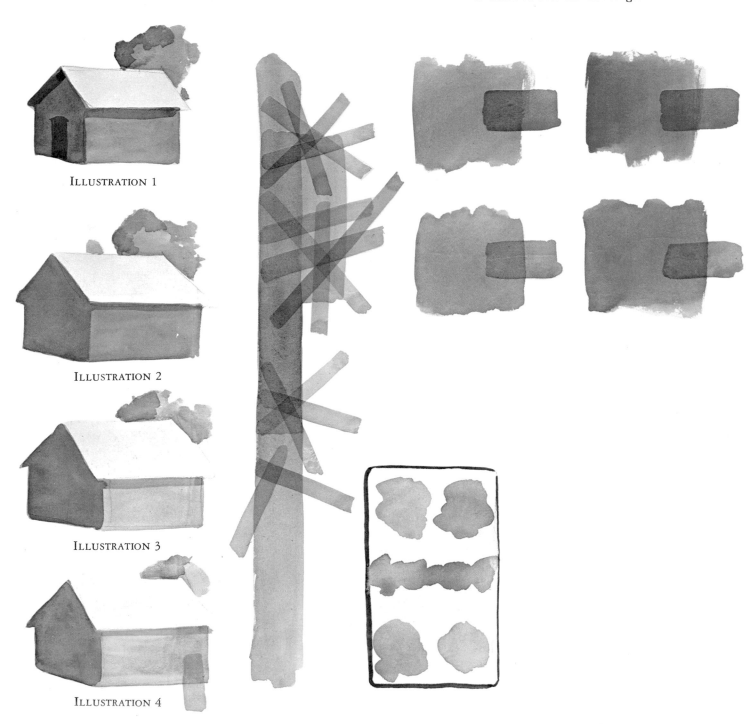

ILLUSTRATION 1

ILLUSTRATION 2

ILLUSTRATION 3

ILLUSTRATION 4

I want to begin by bringing you a few pointers on painting buildings. First of all, the building has a local color. Local color is the basic color of an object. If a house is brown, it is brown all over, not just on the sunny side. Paint your buildings the local color first. The source of light determines what's in shadow. One side of a house or barn will be away from the source of light. This side is the form shadow. If cool values, like blue, are painted on the side of the brown house, it will seem to turn away from the light and have two sides. If the local color of the house is cool, then use a warm color on the side away from the source of light. Of course, you are painting transparent color over transparent pigment, so let the first color dry before adding the second.

Study Illustrations 1, 2, 3, and 4. I want to impress you with the importance of the concept of warm against cool, or cool against warm. You will use it many times in each painting.

Let me add at this point that there are always exceptions to every rule. Some artists draw their pictures and paint in the shadows first. This process requires pretty complete drawing at the beginning or the shadows on the ground and on other objects will flatten out the shapes.

For this lesson, we shall paint the picture on the next page. Note, I have given you all three processes in one picture. Read from right to left. The first third shows how you wet the paper and put in the underpainting. Do not go too dark, use a thirty percent mixture of pigment, and keep soft edges. After the underpainting is dry, paint in the middle values as in the middle section. Last, complete your picture with the darks. Paint behind the grasses as in the illustration.

Select your own palette and complete the picture.

Lesson 5

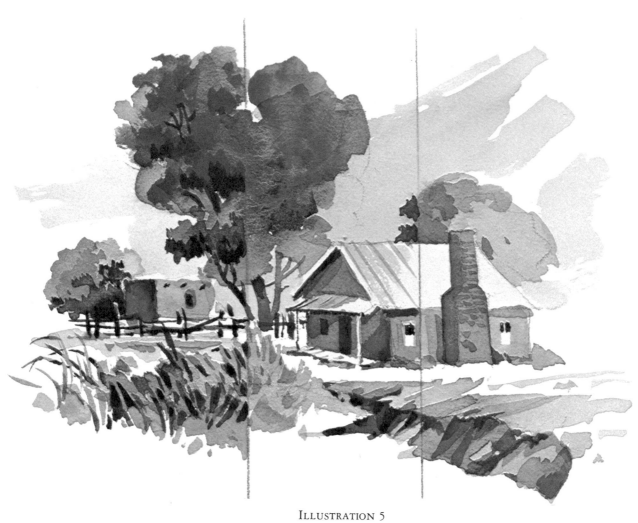

ILLUSTRATION 5

Critique

Did you build your picture gradually, step by step? Surely you didn't go to the darks too soon.

When you made the form shadow on the front of the house, did you also make the shadow at the side under the eaves of the house on the shadow side of the chimney?

Is your grass too stiff? Were you able to make the gully? We shall study this in detail later, but it is good practice to try.

Did you paint the roof of your house? Objects such as roofs, rivers, and roads should be painted last so you will know just how much color you need.

Did you forget and paint up to the house?

Did you put in every brick in the chimney? Don't. Suggest the bricks by making a few and leave the rest unsaid.

Did your green tree form the right side of the roof as in the illustration?

Do you have open spaces in your trees with well formed branches showing?

Try to count the times you used warm against cool or cool against warm.

A Landscape Study in Values

Every artist was at some point a beginner.

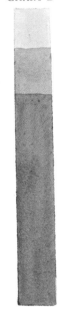

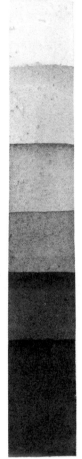

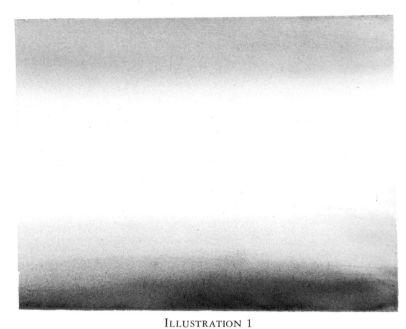

ILLUSTRATION 1

CHART A

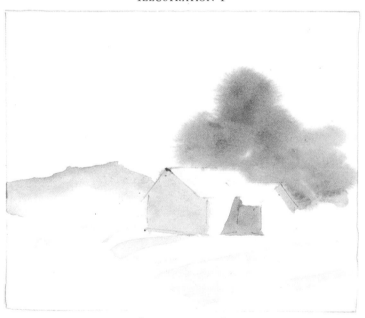

ILLUSTRATION 2

CHART C

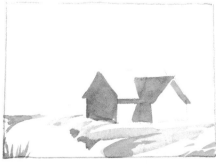

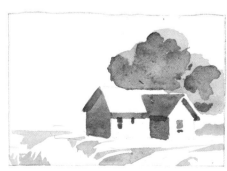

ILLUSTRATION 3

ILLUSTRATION 4

The best way to see values is to look at them in grays where you are not influenced by color. It is really better to use black and white photographs when you paint from reference pictures because you have a clearer presentation of values. This lesson should be painted in gray just as it is in the illustration.

First study the full value gray scale (A) at the left of the opposite page. You begin with about a twenty percent mixture of Lamp Black or Ivory Black and water. Do not change your mixture throughout the picture, but every time you paint over an area, you deepen the values, as you can also see in B and C.

Begin with a graded wash as in illustration 1. Mix a pool of liquid gray on your palette. Make enough for your neighbor and your brother and sister. In other words, have enough liquid pigment mixed. With a loaded brush, lead the paint across the page with a bead. A bead is the pool of color that drains toward the bottom of liquid pigment when it is applied to paper placed on a slanted surface. Keep dipping the brush in the pool of pigment and make sure the loaded brush preserves the bead, as little by little you lead the paint across the page. Add more water as you come down the paper so that the horizon area is clear water. Let dry.

Turn the paper upside down and repeat the process. Allow this wash to dry completely.

Study Illustration 2, and from the same pool of liquid, add the mountain, house, trees, and ground to the first step. Allow it to dry.

Illustration 3 shows the same mixture added on top of certain areas for a deeper value. The contour lines that turn down to the road are deeper, the shadows under the eaves and on the roof are added, and form shadows on the house are deepened. In Illustration 4, values are added as shown. In Illustration 5, small background trees, shadows, grasses, posts, and details are added as you like, to complete the picture.

Lesson 6

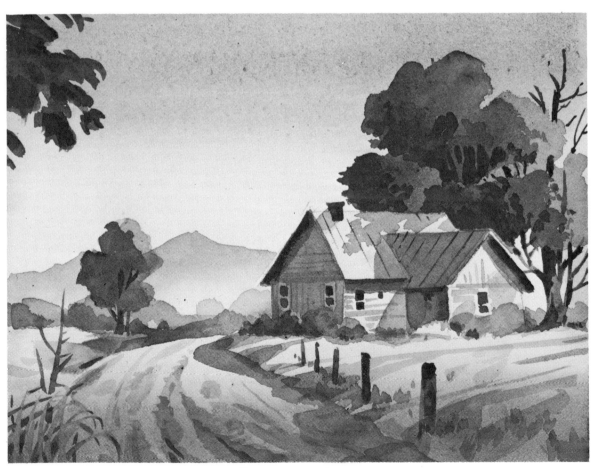

ILLUSTRATION 5

Critique

At a distance study your picture carefully.

Do your values read? Study Illustration 5 again.

Did you put your horizon in the middle so it cuts the picture into two equal parts? I hope not. The horizon is low in the example.

Is the road solid? Is it outlined? Is it white at the back? Look at the road in Illustration 5. As it is lost behind a curve in the distance, the nearest side stops in front of the back side which curves on a bit.

Are your trees interesting shapes with open spaces where branches show through?

How about painting this picture again, using one color like Raw Sienna or Ultramarine Blue? Later you may want to paint it in a limited palette of your own selection.

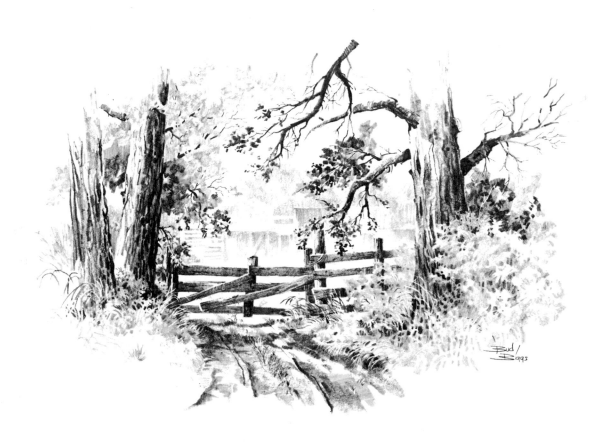

34

Part Two

Elements
of Design
Space &
Shape

Space and Dimension

*Through the artist's use of space,
the illusion of distance and depth
is made possible.*

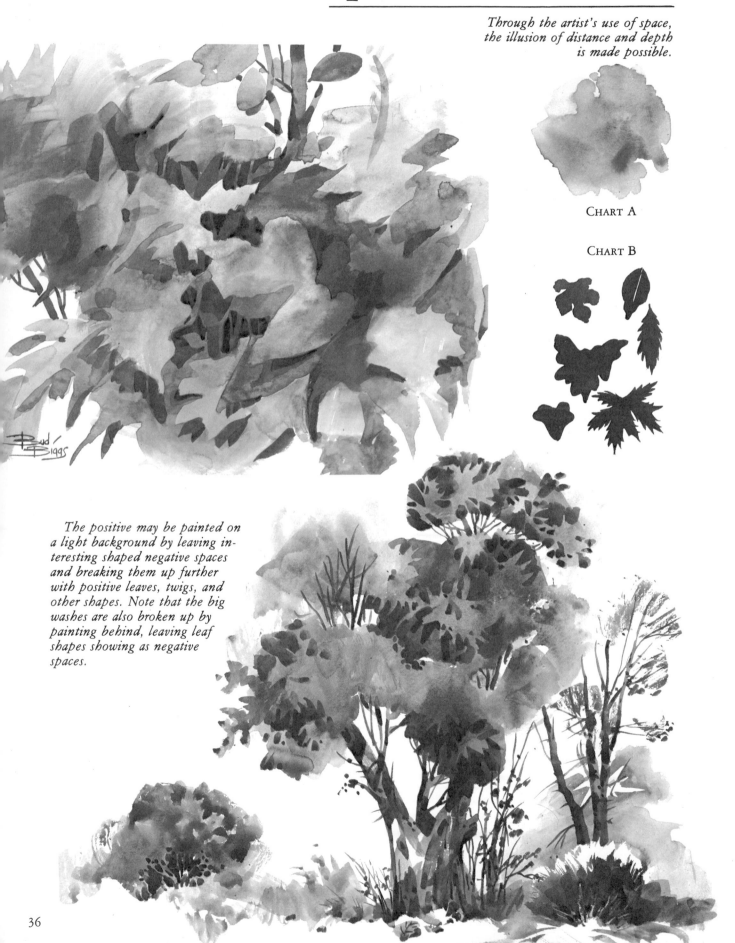

CHART A

CHART B

The positive may be painted on
a light background by leaving in-
teresting shaped negative spaces
and breaking them up further
with positive leaves, twigs, and
other shapes. Note that the big
washes are also broken up by
painting behind, leaving leaf
shapes showing as negative
spaces.

The watercolor artist has a two-dimensional piece of paper on which to work. It is just so long and so wide. Within this area, there must be created a feeling of distance as infinite as the sky. At the same time, some things must appear so near, the viewer wants to reach out, feel the roughness of the tree trunk or the feathery softness of a petal. Space exists in a painting only as an impression, but it gives life to visual design.

Structures, trees, and other forms have substance and the space they occupy in the picture is sometimes known as occupied space. Unoccupied space is the area around them. Hold your right hand at arms length and extend your fingers. Your fingers represent occupied space. The area between the fingers is unoccupied space. Even if you stretched your fingers out so the space between is almost even, there is still a difference. Note the space between the thumb and forefinger and between the little finger and the ring finger. Now, move two of the fingers closer together. Notice how the change in the space changes the entire design pattern. Space is a very important design element.

The artist has many tools to help create the illusion of depth and distance. Objects become smaller and have less detail as they recede; colors become cooler, and values come closer together. Shapes that overlap tend to create a feeling of depth. Dimension in a picture does not have to be great to be important. In this lesson, a few leaves are seen with unoccupied spaces between them. You can look back into these areas and see stems and smaller leaves, but this dimension of only a few feet is the essence of the picture.

Before you begin this lesson, go for a walk. Collect all the different shaped leaves you can find for reference. Imagine that these leaves are all the shades of yellow and red that autumn can paint. Refer to the leaf shapes in Chart B.

Wet your half sheet of watercolor paper and paint a large splash of New Gamboge and Alizarin Crimson as in Chart A. Be sure there is plenty of pigment in your brush.

Lesson 7

You have water in your paper, and if you also carry too much water in your brush, the result will be a thin, pale color. Do not try for any pattern, your purpose is to have the colors bleed and interlock. When your colors are a beautiful array of yellows and reds and all the mixtures of colors in between, drop in jewels and walk away.

When your paper is dry, study the transparent colors. These colors are the lightest that you can use in your design, because, even though you use exactly the color again, you will be painting color over color and that makes a deeper hue. Mix up a pool of yellow and red, and another pool of yellow and red with a little blue in it. Fill a brush with the first color and shape a leaf. Wash your brush clean or use a second brush with only water in it, and wash away the outer edge. When you are making leaves, design one edge and lose the outer edge, then you can return later to the area. You shaped a leaf by painting behind it, not on it. We shall call this process, painting behind. You painted the unoccupied area around the shape, rather than the leaf itself. It is a very important concept, and you will use it often.

That area around the leaf now is wet, so leave it and go to a dry area. In the same manner, shape another leaf, not like the first, and wash the outer edge away. Make all the different shaped leaves you can without going back into any of the wet areas. Let me repeat. The paper must be dry before you go back into it.

Using the second color you mixed which is somewhat darker and cooler, paint leaf shapes and stems into the darker areas around the leaves. Make leaves behind leaves. Paint behind stems and small leaves. Each time, paint behind a leaf or stem, wash your brush clean, and lose the outside edge. Work around all over the picture. Let it dry each time before you go back into an area.

Continue going back and building up until you have some deep, transparent darks. Do not scatter your darks. Build them up, not in the center, but near the center next to some of the light values you painted first.

Critique

Are your colors all transparent with many beautiful values? Where you painted behind the shapes of the leaves, do you still have transparent colors, or did your paint become too thick and opaque?

Be sure you didn't cover up all your first values. Some of these should always be left to create lights in well chosen places.

Did you drop in some jewels?

Did you wash outside edges so they do not show? If you used dirty brushes or dirty water, an edge will form. Did you wash out your brush like you wash clothes, clean?

Are your darks interesting and well placed?

Don't put your details in the light areas. Put them in the dark areas. Keep the darks away from the outside areas of the picture.

Do you feel you can look back into the darker areas around the leaves and still see stems and leaves? In other words, is there depth?

Maybe this one didn't come out right this time. Don't pass it by. Try it again and again, until it pleases you. Painting behind is one of the most basic skills in our entire study. We shall use it in almost every picture we paint. This time it was leaves. Next time it may be a house, a fence, or a rock. Perfect your skill through practice.

Creating Space—
Painting Behind

Paint it pretty!

ILLUSTRATION 1

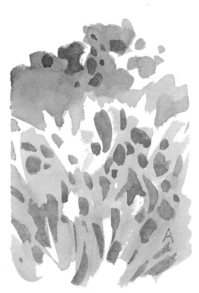

ILLUSTRATION 4

ILLUSTRATION 2

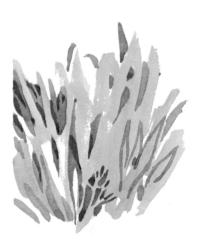

ILLUSTRATION 5

ILLUSTRATION 3

ILLUSTRATION 6

This lesson demonstrates a method of creating space behind bushes, grasses, and foliage. The first step is to paint beautiful color in which to work. Flat color is dull and uninteresting. Look at Illustration 1 at the beginning of this lesson. A wash of blue green was painted. When that was dry, a wash of yellow was added, and later a band of brown. There are three distinct colors with hard edges where one color joins the other. The colors are transparent, but the picture has lost the beauty and the magic of transparent watercolor. In Illustration 2 the colors have interlocked, one bleeding into the other to make a myriad of subtle color changes. There are no hard lines. This is better, but not good enough. In Illustration 3, one more thing was added. Jewels were dropped into the wet colors. It is this beauty you want to achieve on your paper before you do any painting behind. Practice this important step until you know just how much water and how much pigment to use. You need to develop a feel for this sort of thing. Drop in jewels. Let it dry; then stand off and give yourself a critique. Did you paint it pretty?

Study Illustration 4. Discovering the secret of painting behind is a bit like cutting a hole in a balloon to see what makes it work. When you see it completed, it all looks related and gives you the impression of looking back into the dark spaces behind. Actually it's quite simple. First, just paint it pretty, paying no attention to bushes, trunks, and other shapes. Then, as in Illustration 4, use a pencil, a brush, or whatever you are successful with, and draw in the trunks and branches. After you have drawn in an interesting shape, paint in the area around the trunk. See how the color is around the branch and not *on* the branch? Soon, you will be able to accomplish this without drawing it in first. The last little bush on the right, in Illustration 4 is positive, that is, branches are painted in and not behind. In a group of bushes, make some branches both ways.

Lesson 8

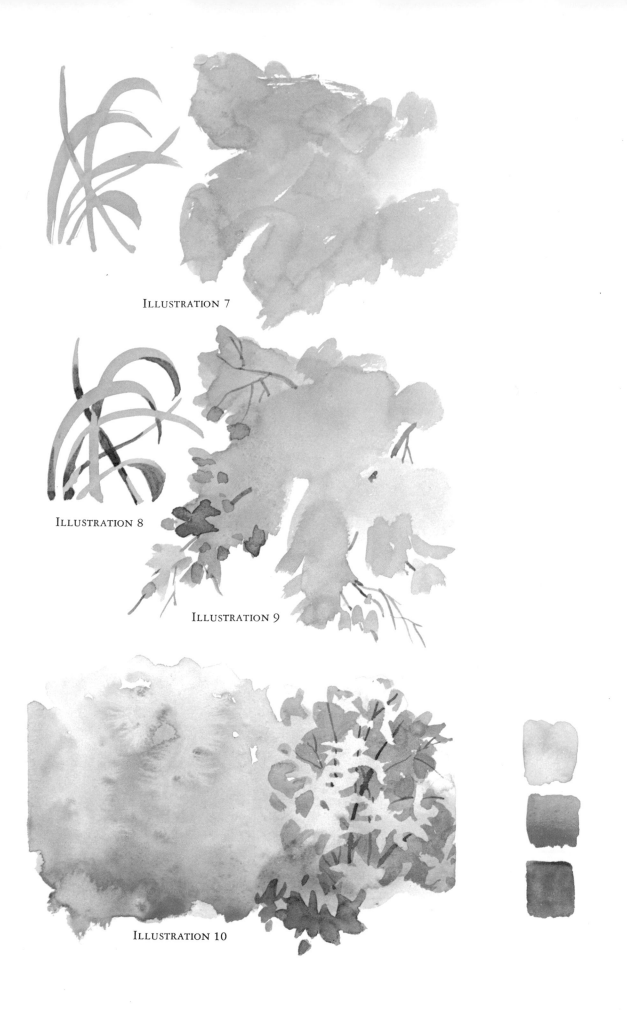

ILLUSTRATION 7

ILLUSTRATION 8

ILLUSTRATION 9

ILLUSTRATION 10

In Illustration 5, the spaces are painted in between the tall grass. See how the white and yellow grass stands out gleaming in front of the dark areas? Again some positive grass is also painted. Don't just study these illustrations. Practice them until you master the skill. You will love the effect of the tall grass in your pictures.

In Illustration 6, a variety of shapes have been painted in the foliage area behind the yellow leaves that show out in front. In Illustration 7, some grass blades were painted and in 8, the back section of the grass was darkened to give depth. Also, in Illustration 9, study and practice the leaves. See how the edges are shaped and identified by painting behind?

As in Illustration 10, first, paint it pretty. Let it dry. Paint behind shapes of leaves and foliage. The foliage that is left seems to be in the sun. Branches and trunks were painted in the shadow area. Do not paint in the light area, paint in the shadow areas.

Practice making bushes of your own. Use different colors and different shapes. But remember, first of all, paint it pretty!

Negative and Positive Spaces

When you paint a value into a space or shape, it is positive.

When you paint behind it, you leave the negative space or shape.

ILLUSTRATION 1

All space has a part in creating the illusion of nearness, distance, and depth. When we paint on a space, we shall call it positive because we are painting on it. The space or shape we leave is the negative.

Study carefully Illustration 1 on the opposite page. The top of thin branches reaching out from the tree are painted on. They are positive, but notice how they break up the negative area around them. It is important to look at what we are leaving when we paint positive shapes.

Next, the foliage was painted in and the branches were left as negative shapes. Notice how the dark foliage is used to shape and space the negative branches.

Coming on down the tree, the branches are painted as positive shapes giving form to the interesting and important negative open spaces between the large branches.

Then the positive dark tree in the background is painted to form the negative trunk. This positive tree also shapes the fence and house top. Note that the fence is both positive and negative. Black was painted on the lower trunk to allow the use of negative areas in the trunk near the ground.

The important lesson here is to understand that when you paint *on* a shape, it is positive, and you use it to form negative shapes. As you paint, look at what you are leaving as well as what you are painting.

For this lesson, practice painting the positive shapes and the negative shapes in this picture until you get the feeling that you are really painting what you are not painting on at all. In other words, you are painting to make the shape of important things you want the viewer to see and admire, but you are accomplishing this feat by leaving unpainted the part you want to bring out. Where it's dark, it's light, and where it's light, it's dark. In other words, where it's dark, you want the viewer to see the light shapes. Where it's light, you want the viewer to see the dark shapes.

Lesson 9

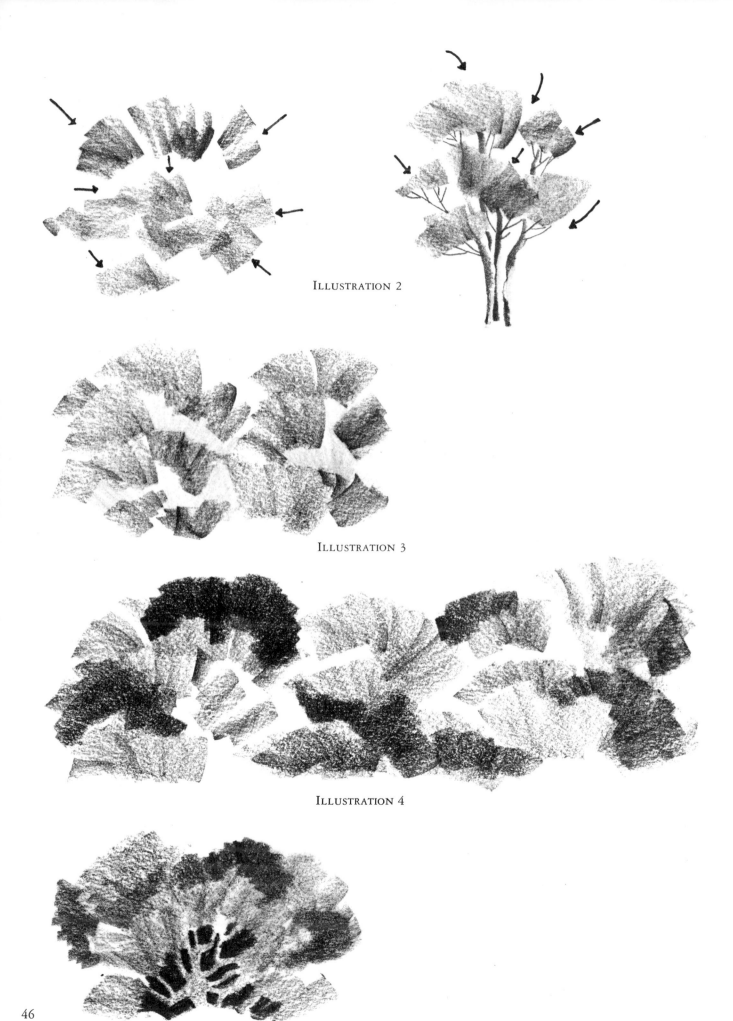

ILLUSTRATION 2

ILLUSTRATION 3

ILLUSTRATION 4

46

ILLUSTRATION 5

Try this lesson several times until you get the feel of it. Compare your paintings with the illustration. This illustration is black and white for clarity. The process is the same thing as painting behind in color. This method makes an exciting accumulation of lights and darks in a picture. The illusion of the negative space becomes real. The better you master this lesson, the better your pictures will become.

Illustration 2 shows that brush strokes for tree foliage should not go straight across the page parallel with the bottom of the paper. They should resemble the outgrowth of clumps of leaves and should make open spaces in the trees. These spaces are very meaningful and open up a tree. They should be large and convincing, large enough for a golf ball to go through.

Illustrations 3 and 4 show clumps of bushes. Some of the foliage is always in shadow and should be darker. The brush strokes are similar to those used in the trees in the above illustration.

Practice painting behind the branches and twigs of some bushes as in Illustration 5. Perhaps by now, you are able to paint these in without drawing them first. Practice, practice, practice.

Shapes

*No two shapes should be alike, and each
one should be interesting.*

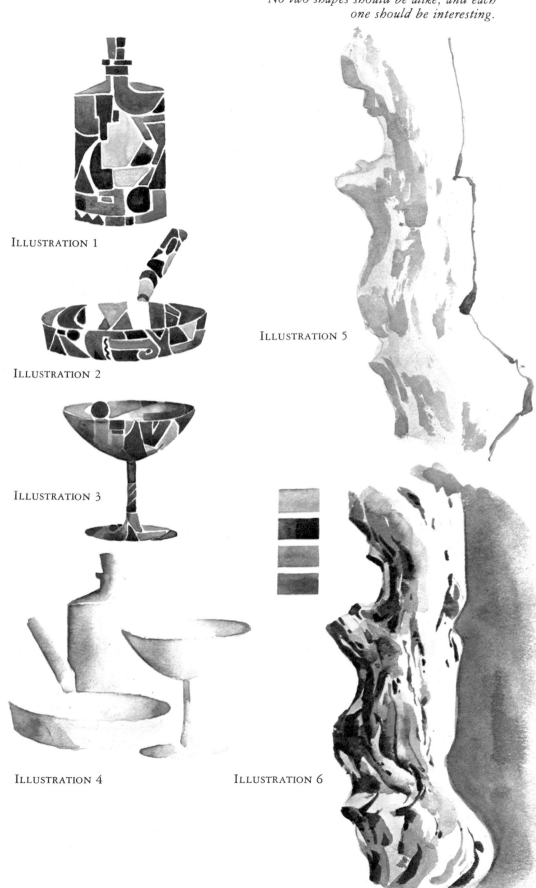

ILLUSTRATION 1

ILLUSTRATION 2

ILLUSTRATION 3

ILLUSTRATION 4

ILLUSTRATION 5

ILLUSTRATION 6

When you use a group of lines to encompass an area, you create a shape. A shape occupies space. The surrounding area or space also has shape, whether it is background of sky or the smaller space between two trees. All these shapes are important, and they should be different and interesting.

How many shapes can you make? Try and see. Usually students come up with the geometric shapes, oval, square, rectangle, triangle, and circle. How many shapes did you make not included above? The geometric forms do not prove to be as interesting as the myriad of different shapes you can envision with a little effort and practice.

Study each shape placed in the area of the bottle in Illustration 1. How many are there? Did you count the white shapes? Remember they are shapes too. You design the negative by painting the positive. The most interesting shapes have very odd outlines. Try your hand at outlining a bottle and see how many different shapes you can paint in it. Invent your own. It's really not as easy as it sounds to make that many different shapes, is it? To achieve different shapes, make the first one. Then make the next one different, and the next one different to that one, and so on. Try the pan and the wine glass. (Illustrations 2 and 3.)

This practice is to make you conscious of how many interesting shapes there are. Your picture is made up of shapes. Some of them will attract more attention than others because of location, contrast, size, color, value, texture, or detail. These should receive special attention.

Illustration 4 shows you where the shadows go that give roundness and form to shapes. These shadows are made a special way. With a brush loaded with liquid Ultramarine Blue and a little Alizarin, begin painting at the shadow edge and go only a short distance. Wash your brush clean. Begin painting water at the other edge and lead it into the liquid color. Tilt the page back toward the color edge until it dries. These form shadows are the subject of a later lesson, but here, I want to say that as important as shape is, there is one more step needed to give substance to a picture. Form shadow! The wine glass in

Lesson 10

ILLUSTRATION 7

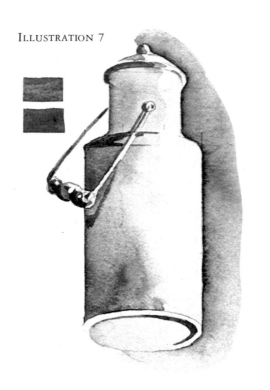

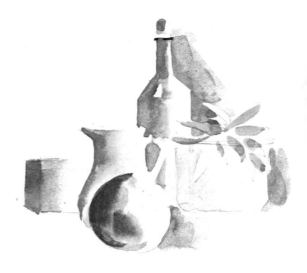

ILLUSTRATION 9

ILLUSTRATION 8

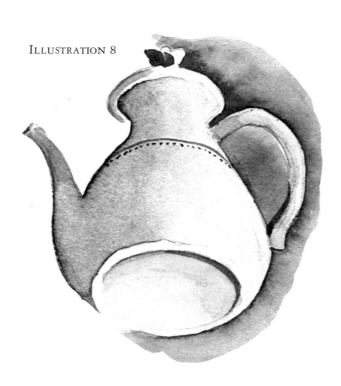

ILLUSTRATION 10

ILLUSTRATION 11

Illustration 3 has the form shadow. See how much rounder it appears than the pan or bottle?

The driftwood in Illustrations 5 and 6 is a review. Remember your lesson on transparent color? Start with blue. Practice making transparent colors read. Remember the lesson on painting behind? The right side of the driftwood is made by filling your brush with about a thirty percent mixture of Burnt Sienna and shaping the side of the stump by painting in the background. The outer edge is lost with clear water in a clean brush.

For additional practice try the still life in Illustrations 7 and 8. Draw the shape. See how flat it appears? Paint the form shadows as described above. Form the other side by painting behind. Practice this exercise several times.

Your complete picture for this lesson is Illustration 11. Study it carefully before you begin. Note especially how the negative shape is left by painting the positive. Begin by painting Illustration 9. Only the shadow side is painted. It has soft edges because it was accomplished in the manner described above. Not all form shadows are blue. Sometimes they take on the color of the object itself. The next step is shown in Illustration 10. It suggests some decorative features that can be added. Note that when you add the decorations to the still life, they do not destroy the roundness created by the shadows. Note also the shadow sides of the leaves. Last of all the local color is added, some cast shadows also are seen. Try these.

This exercise should be a fun picture as well as a lovely still life. Try again with some still life shapes of your own choosing. Place a light to one side of your arrangement to enhance the form and cast shadows. Later, you will study form and cast shadows in landscapes.

Shapes, Spaces, and Color

Somehow you must learn new things, but you must develop the skill to use all you have learned to combine it into a work of art.

ILLUSTRATION 1

ILLUSTRATION 3

ILLUSTRATION 2

ILLUSTRATION 4

As you proceed to learn new methods and gain fresh insight, you must not neglect those things you have already learned. At this point, I want you to look again at what you have learned about transparent color, jewels, value, space, shape, and painting behind. We shall move swiftly. At any point that you feel you need more information, return to the lesson of that subject and reread and repractice that particular topic. Each lesson may include new material, but it must be built on the foundations that have already been laid. You are not competing with anyone except yourself. You are your own master, artist, and critic.

Using autumn colors and your knowledge and skill, paint Illustration 2. Study the intermediate stage shown in Illustration 1.

Now sit back and critique your efforts.

How about the shape of your color? Does it look like a lollipop?

Examine the color. Is it washed out and pale? You did not use enough pigment. Did it dry flat even though you used many bright colors? You did not use enough pigment. Is it opaque? You did not stir your color.

Examine the shapes of your trunks and twigs and also the shapes of your darks. Are they convincing? Are they interesting or do they look like sticks? Do you feel that you are looking far back into bushes behind trunks and branches?

Lesson 11

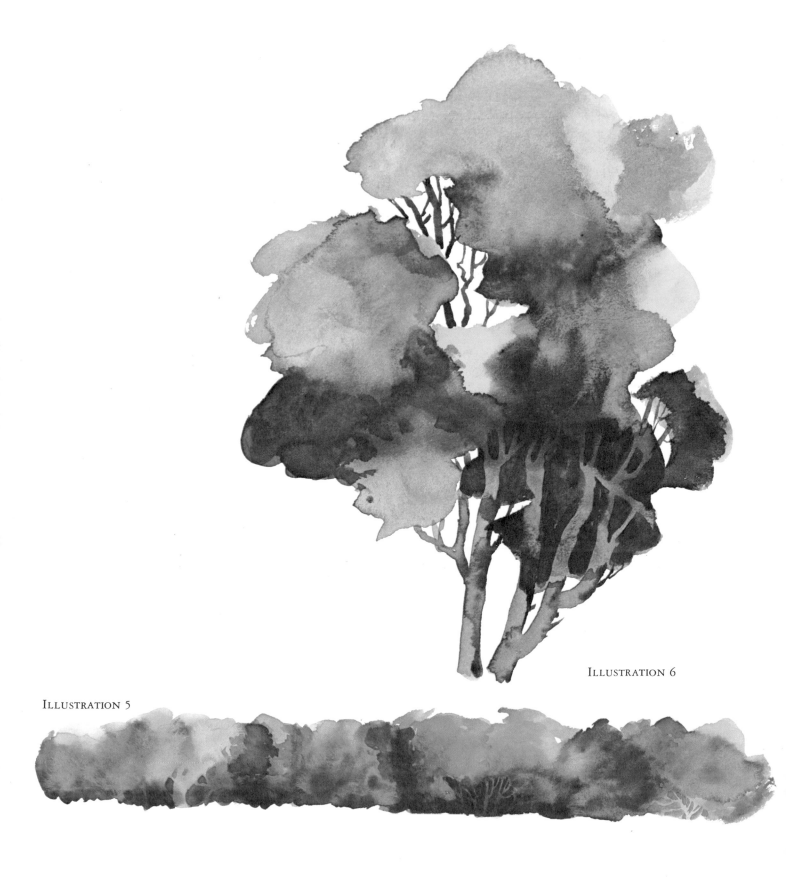

ILLUSTRATION 6

ILLUSTRATION 5

Practice the same thing using the green colors of spring and summer as in Illustration 4. Make your trunks and twigs different from the ones you made previously. Repeat the above critique. Perhaps you can paint behind these branches without first drawing them as was done in the intermediate stage shown in Illustration 3.

Illustration 5 shows how a whole forest can be created using the same painting procedures.

Now try the tree in Illustration 6. When you have finished, look at the picture in the example along with your painting and ask yourself these questions. Be honest!

How about your color? Did it run and bleed and yet hold its identity? Good, you are coming along!

Examine your shapes, both those that are painted behind and those that appear out in front. Are they different or did they come out alike?

Examine the negative spaces. Are they different in shape? Trace around them with your finger so you can visualize them better. Remember, open space also has shape.

Are your trunks and branches an interesting pattern? Are they black? Look at the ones in the example. They stand out and are easily seen, but they have the same color as the tree itself. Practice putting on some pigment liquid —enough to borrow from to form the next section of the trunk. Drop in jewels. You will come out with gleaming, interesting trunks and branches that are related in color.

Do your branches break up the negative spaces in an interesting manner? To show the shadow, paint a darker color on the branches where they twist and turn away from the light.

All these things do add up to a lot to remember at one time, so practice often. Every once in awhile, go back to the first of the book and repeat the lessons. You will be surprised how much more it will mean to you now that your experiences and knowledge have increased.

Painting Shapes from a Photograph

Happiness is watercolors, a brush, and some paper.

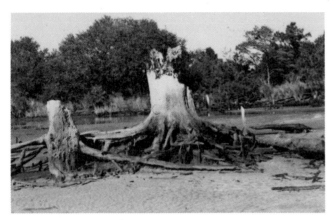

ILLUSTRATION 1

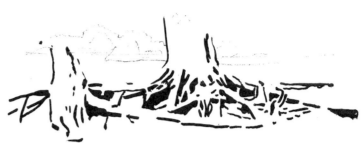

A.

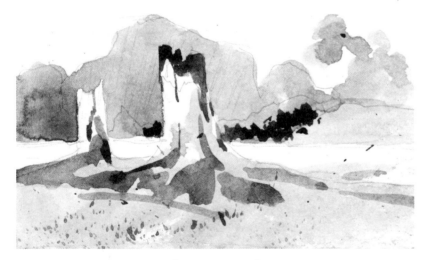

ILLUSTRATION 2

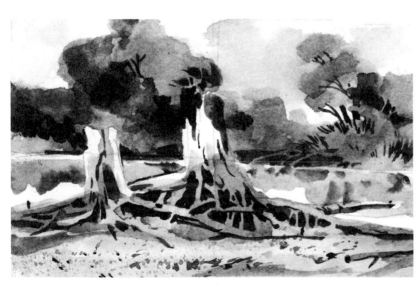

ILLUSTRATION 3

B.

Illustration 1 on the opposite page is a black and white photograph taken of two stumps in the bayou country. Photographs, by their very nature, depict objects in detail and may be, therefore, confusing. The artist's task becomes one of simplifying, eliminating, and shifting things around.

To understand a photograph better, place a small piece of tissue paper over it as in example A. Use two paper clips to fasten it in place and pencil in the positive shapes which also describe the negative forms. You will have a simplified picture without detail. Plan your painting from this small, simple sketch. Rearrange and eliminate. Are the darks well placed and interesting? Are the main shapes varied, in good positions, and strong enough to compel attention? Plan carefully how you will paint your picture. In this case the background trees will shape the trunks down to the light area, where the trunks will become positive as seen in Illustration 2. You should practice several things before you start painting this picture.

First, practice making the gray scale as in example B. Use Ivory Black and make a twenty percent mixture in a small jar. Make plenty because you will also paint your picture from this mixture. Paint a wash the width of your brush the entire length of your paper. After it has dried, drop back a half inch, and, using the same mixture from the jar, paint a wash over the first. After this has dried, drop back about a half inch and repeat the process until you have done it nine times. These are the values you will use for your painting. The entire picture should be painted from the twenty percent mixture in the jar, applying twenty percent gray over dry gray until you reach the darks seen in Illustration 3.

Second, practice making the roots as seen in Illustration 5. Study their shapes. No two of them are alike. Paint the dark area encompassing the roots as seen in Illustration 2. Let it dry. Now, it will be very much like putting shapes into the bottle, wine glass, and pan just as you did in lesson 10. You will paint your shapes to look like roots and place them in the dark areas. Paint positive shapes behind these roots and leave the negative roots. Practice this exercise until your roots are convincing. Study and practice the enlarged examples in Illustrations 4 and 5.

Lesson 12

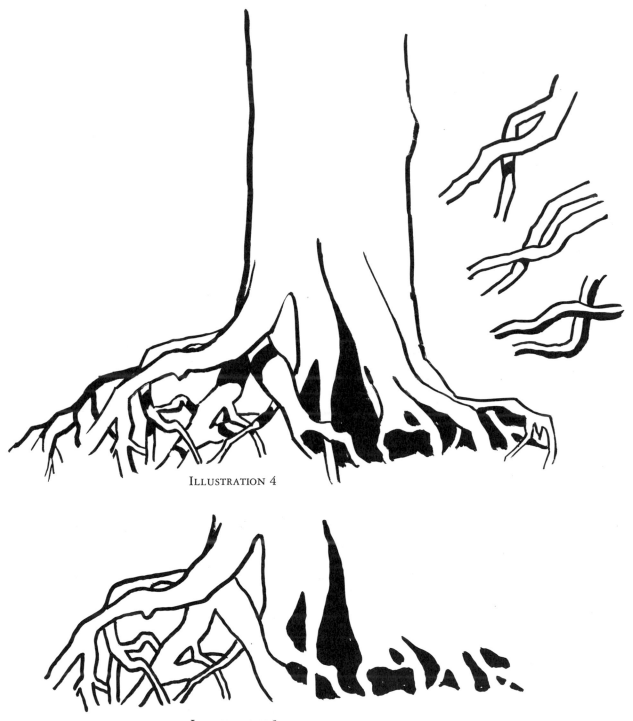

ILLUSTRATION 4

ILLUSTRATION 5

When you are satisfied with your practice efforts, sketch on a half sheet of watercolor paper the position of the two trunks. That is all you need. Wet the paper, use the gray you already have mixed in the jar and complete the underpainting. This will be light. Remember, you will keep coming back with the same mixture of paint at least nine times before you complete your picture. Apply all you have learned about making interesting shapes, painting behind the roots, building up the interest areas.

Critique

When you look at your completed picture, are you aware of the value changes throughout? Did you cover up all your first underpainting or leave some to form the lightest values?

Did you cover all your white or did you leave some gleaming in the interest areas?

Do you have darks against light as you should have?

Are your values a subtle build-up? This method of using the twenty or thirty percent mixture in the bottle is excellent discipline for an artist. Students get excited and want to go suddenly to the darks. This mixture makes you earn the darks by having to go back in different areas, but the result is seen in subtle value changes that enrich a painting.

Study your negative and positive shapes. Look at them all over your picture. Did you get in a rut and make them alike?

In Illustration 3, pick out the value changes. Can you find similar value changes in your picture?

Do not let the horizon line cut the picture into two equal parts.

Using a twenty percent mixture, paint this same picture in blue or in just one other color of your own choosing. All your values must be obtained from the twenty percent mixture by overpainting after each application has dried.

Do you like the close values and subtle changes?

How Do You Begin?

When you plan a watercolor picture, aspire to capture the beauty of your concept and share it in an eternal form.

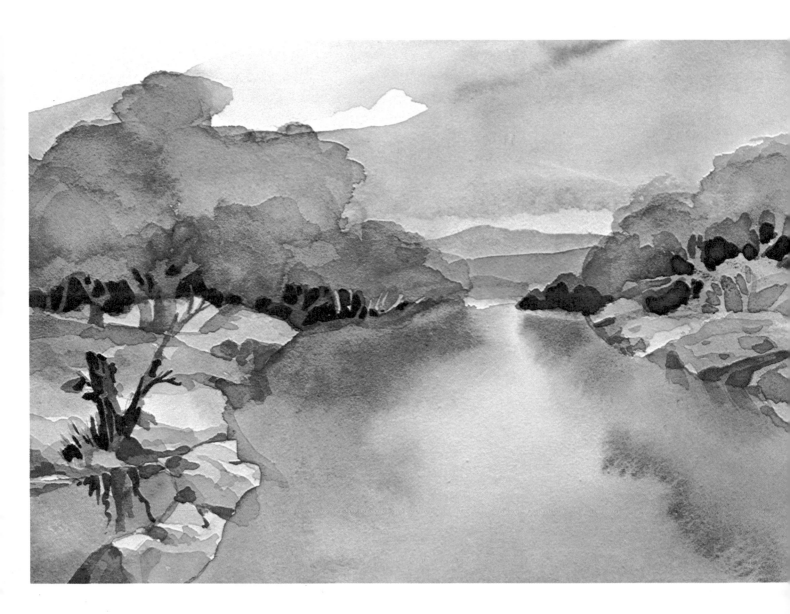

Perhaps the essence of all art begins with the dream and the vision of the artist. It is somehow the compelling force that drives him to work long and hard to try to share that inner beauty. It is especially true of watercolor painting that the beauty exists in the mind of the artist first. Watercolors demand special planning, and there are two distinct stages. The first stage is the mental picture and the second is planning how to go about the best way of painting the picture. These two steps must be more complete in watercolor than in some media because the white paper and the transparent lights must be captured from the very beginning or they can never be recovered in their full beauty.

I have a keen desire to know my readers personally as I want to know all my students. But this one thing I know about you. You have inner beauty that you want to share or you would not even be reading this book. Develop this creative urge. Don't copy pictures from books. Be original. Keep a classified file of folders in which you place photographs, clippings, sketches, and other references. You may prefer to paste your pictures on cardboards cataloged by special topics. Take a tree from this photograph or a house from that and create your own composition. When you go on location, don't just reproduce exactly what exists. Ask yourself, ''Why do I want to share this experience? What beauty do I want to share? What is it I want to say to the viewer?''

Create your own compositions. And plan them to say the *one* thing you want to say in your picture. To try to say more than one thing in a picture is confusing. This is not easy and you may be shy, unsure, and lack confidence at first. Be assured you will improve with practice and experience.

Many students ask, ''How do I begin painting? What do I do first?''

Plan step by step. Plan colors, values, shapes, and spaces. Do not think of painting a tree, paint a shape. Let the branches break up the negative area into many and varied shapes. Plan warm against cool. Plan negative and positive shapes. Many artists, even accomplished artists, practice painting a small picture before they go to the full size. Plan your palette.

Lesson 13

ILLUSTRATION 1

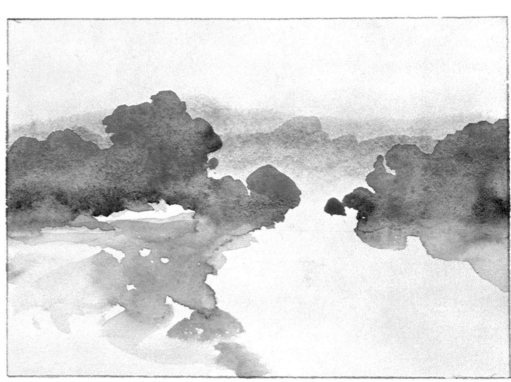

CHART A

ILLUSTRATION 2

62

Study the painting at the beginning of this lesson without peeking at the other illustrations. How would you begin? Jot down on a sheet of paper your first step, your second step, and so on. Don't forget to list drying time where you need it. Compare your plans with the suggested steps I've shown.

Here are the steps I feel will best help you paint this picture.

ILLUSTRATION 1. First, turn your paper to the back and massage the paper with a wet sponge. Then wet the top side and tilt the page to let the water run off. While you are doing this, the water will saturate the paper, and you can paint beautiful soft edges. Do not sketch this picture, paint it. Begin with the shapes of the distant mountains. There are two with individualized shape and design. Carry plenty of pigment in your brush because there is water on the paper. Stir the color well as you use it.

ILLUSTRATION 2. Study the colors in panel A. How were these colors achieved?

Drop in color for the trees and river banks. Drop in some jewels. Your paper is drying some now, and the back blue trees will appear misty and the front trees will hold better. They will come forward both because of the firmer shapes and because of the warmer color. Wait a minute! Don't outline the bank beside the water. Drop in color shapes. Let this dry.

ILLUSTRATION 3. Build up the foliage and grass areas after you look closely at the colors in Panel B. Next paint in the sky. Note that the sky does not cover the mountain in every spot. There is a haze, but some of the sky overpaints the mountain for another dimension. Add some of the reflections. They are painted down and follow the shape of the trees in a mirror image. They have soft edges. Let this dry.

ILLUSTRATION 4. Last of all, paint behind the trunks of the trees in the distance, put a shadow side and texture on the rocks, paint in the stump, build up the reflections, and do whatever you feel you might need to tell your story.

CHART B

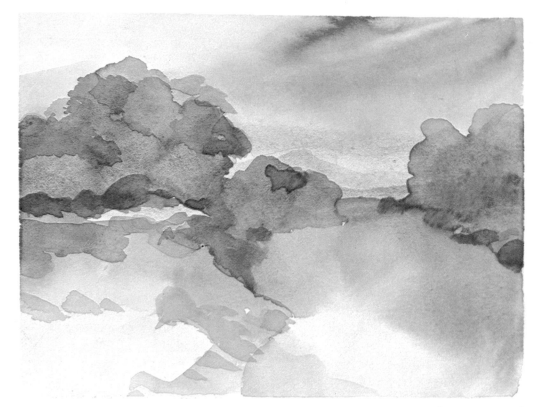

ILLUSTRATION 3

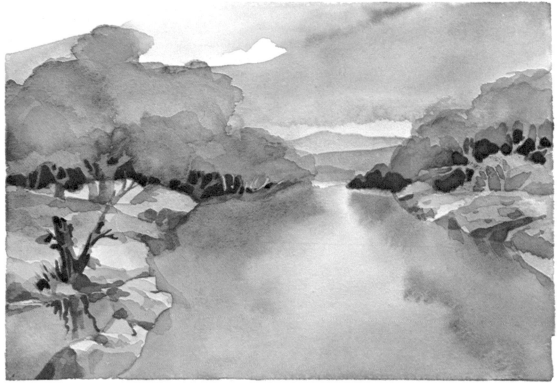

ILLUSTRATION 4

Critique

Do you have soft edges in your picture? Most watercolors perhaps are best painted on wet paper, building from background to foreground as the paper dries.

Are your colors too pale? You did not carry enough pigment in your brush. The sky should not be too light. Sometimes it may be pretty, but the eye goes to the light first, and the sky is not what you want to call to the attention of the viewer in this picture.

The place of greatest interest is the middle distance where the river, sky, mountain and trees come together. Note how the dark trees lead the eye in. I like to call this area the eye of the picture. The viewer's gaze will travel all over the page, enjoying it bit by bit, but the place of greatest interest should pull the eye back into the picture. Here are strong value contrasts; also, the warm sky contrasts with the cool trees and the distant mountains.

Are your reflections soft and exciting? Reflections are painted down, should be liquid, and hold to the shape and color of whatever is being reflected.

Are your colors blended, related, and beautiful, or do they look just like they did when they came out of the tube? Did you drop in jewels? Study again the soft colors in the vertical Charts A and B.

Does the horizon divide your paper in half? It should not.

Plan a picture of your own. Make it a beauty you want to share. Deliberately and carefully plan each part. Plan how you will paint it, step by step. Plan your limited palette. When you have completed it, apply the above critique. Try this experiment several times.

A.

A.

B.

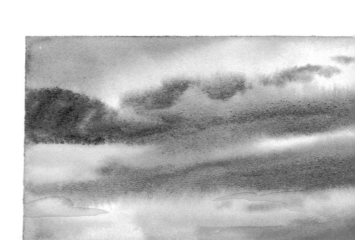

B.

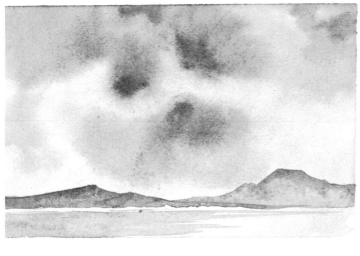

C.

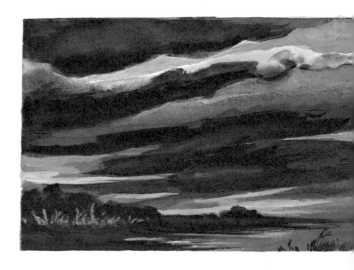

C.

Sky Shapes in Motion

Watercolor has a will of its own,
which is the secret of its charm.

Since the days of our childhood when we lay on the warm summer grass and let the ethereal cloud shapes awaken our imagination, we have felt a kinship with the vast expanse: the ever-changing, never-ending pageantry of the sky. Perhaps every person who has ever lived has at sometime felt an urge to paint a sky. Surely every artist has felt the yearn to capture the sublime beauty of sunsets, clouds in motion, and approaching storms. But watercolor has a will of its own, and you must work with understanding and allow it free motion.

Study Illustrations A, B, and C on pages 66 and 68. Here are the steps to follow to create these effects.

Your sky is the most important part in these pictures, so it will cover most of your picture area.

Wet the paper on both sides and drain off the water.

Use plenty of pigment; you have a lot of water in your paper.

Drop in the lightest values and let them run.

After a bit, drop in the next lightest values. Your paper will be a little dryer and some of it will begin to hold.

Last, drop in the darkest values. The paper should be dry enough that cloud shapes will hold. Do not try to shape them with your brush, let the watercolor have free motion. Paint whatever you want in the small area of land.

Lesson 14

A.

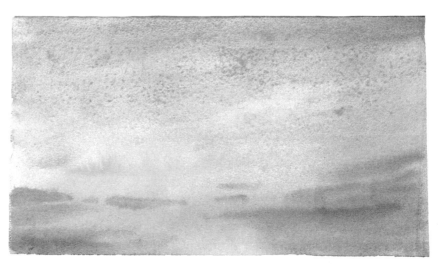

B.

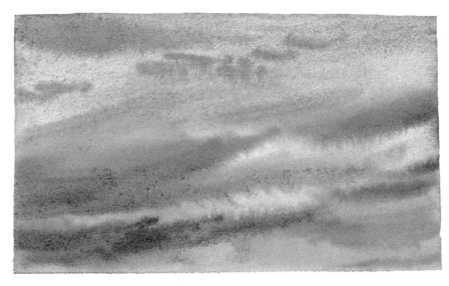

C.

ILLUSTRATION 1

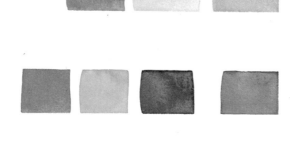

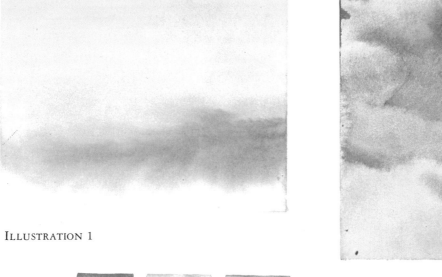

ILLUSTRATION 3

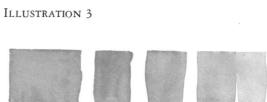

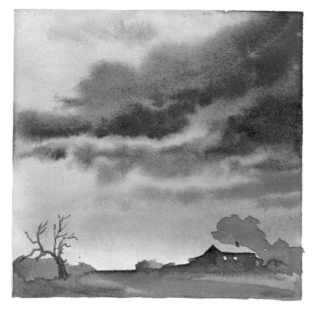

ILLUSTRATION 2

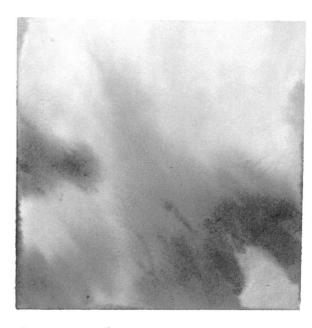

ILLUSTRATION 4

The next group of sky illustrations are made a little differently. In Illustration 1, paint on the lightest values first and let them dry completely. Then rewet the sky lightly with a large brush and paint in the cloud formations as in Illustration 2 tilting the paper to let it run. Use enough pigment but make it juicy. Paint in the small ground area after the paper has dried.

The cloud formations in Illustration 3 were painted with the paper upside down and slightly tilted.

In Illustration 4, the paper was turned sideways, pigment was dropped in at the top edge, and the paper was tilted so the pigment would run down through the paper, making interesting formations. Later, while the paper was still wet enough to run, pigment was again dropped into the same edge and the paper tilted. This time it held with beautiful soft edges trailing off into the clouds.

Make yourself some beautiful sunsets and clouds. Go on, have a ball. Make a lot of them until you have mastered the art of painting beautiful skies.

Critique

Did your cloud shapes hold? If not, you did not use enough pigment.

Are your clouds opaque? If so, you did not stir your pigment.

If you work on a full sheet of watercolor paper, your sky may become too dry for the paint to run. If this happens, allow the paper to dry completely. Use a large brush, not a sponge, and lightly rewet the paper all over and begin where you left off.

Make sure you have your palette loaded with the pigment you want before you begin so you do not have to stop and mix color.

Remember, it's A, B, C. A comes before B, and B comes before C. In order of painting, it's lightest values first, midtones, and then darkest values last.

Rhythm in Shapes and Spaces

*The artist must listen to the music of the
seasons and capture the rhythm of nature.*

Rhythm is related to a Greek word which means *to
flow*. Rhythm in art is the flow pattern, the movement,
meter, accent. You simply can't be up tight and achieve a
contagious rhythm in your picture. Relax for this lesson.
Turn on your favorite music. Use a big sheet of paper and
work with arm movements instead of fingers. Try to forget
the rules and regulations you have always followed and get
rhythm. You are not growing unless you make mistakes.
Don't be timid.

Look first at charts A and B on the next page.
Moisten your paper then with exciting Yellows, Orange,
and Burnt Sienna, paint a beautiful array of colors as you
did in Lesson 7. Let it dry completely. Study Illustration 1.
This is the general kind of effect you will be working for. I
prefer to use an inch brush to work on this type of design
because, by twisting and turning, many unique effects are
possible.

Your exercise is to paint interesting shapes with your
brush over yellow underpainting. Use a big brush and
don't pencil in any of your shapes. Have a look at Chart C
for ideas but make up your own shapes. Don't repeat the
same shapes—work for variety.

Have fun. Let yourself go . . . do your own thing!
Paint rhythmic patterns.

Illustration 2 is my version of this exercise. No need
for your painting to look like it, indeed it should be your
own solution and quite different.

Lesson 15

ILLUSTRATION 1

CHART A

CHART C

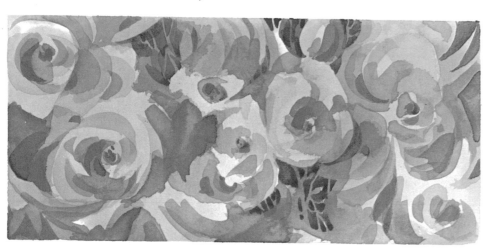

ILLUSTRATION 2

CHART B

72

Critique

Do the patterns flow? Have you achieved rhythm? It is good to have a painting buddy with you so you can exchange critiques.

Are the colors beautiful and varied, with many values?

Are the shapes interesting? How many of them are alike? Each one should be different.

Whatever you did in the upper left hand corner, did you also do in any or all of the other corners? If you did, you are wrong.

Were you able to paint behind the flowers and foliage without drawing first?

Was it fun? Come back to this lesson again later.

Take a Giant Step

A teacher teaches only when a pupil learns.

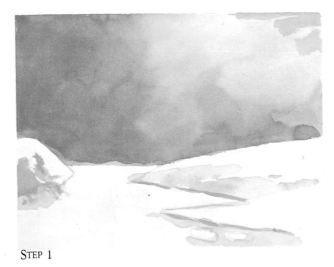

STEP 1

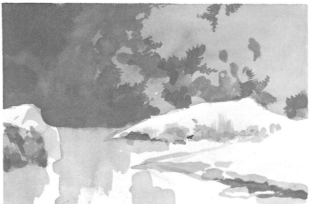

STEP 2

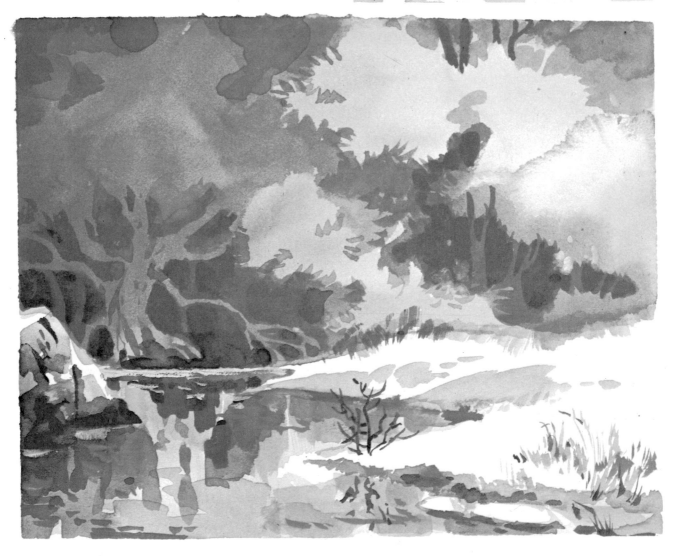

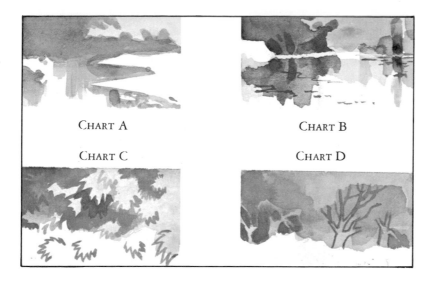

CHART A CHART B

CHART C CHART D

The test of learning is performance. Take your test.

Complete your own version of the picture shown on the opposite page. If you need to do a little cramming first, refer to lessons 8, 9, and 11.

Compare the brightness and transparency of your colors with the illustration in the book. Are you achieving all the brilliance watercolor has to give?

Compare your value changes with those in the workbook. Do you have flat areas? Did you drop in jewels? Do you have any hard edges?

Do you have a negative tree and a positive tree? Study the illustration and see Chart D.

Is the difference clear in your mind? If not, review lesson 9.

Are you able to paint behind the foliage as in Chart C?

Did you paint your reflections down? See Charts A and B.

Are your bushes and rocks convincing?

Is this picture one that you want to keep? Are you painting better pictures? Are you gaining independence? Are you able to verbalize what is right in your picture and what is wrong and why?

Lesson 16

Form Shadow and Cast Shadow

Shadows are the artist's helpmate.

1 FORM SHADOW

2 CAST SHADOW

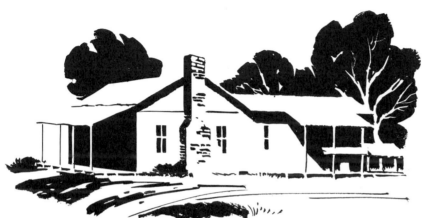

3 COMBINATION OF THE TWO

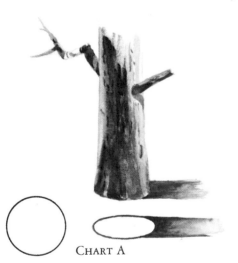

CHART A

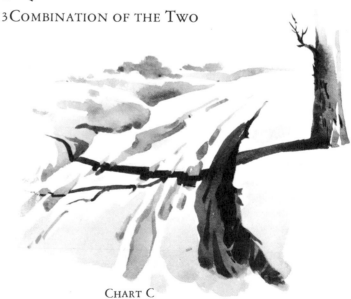

CHART C

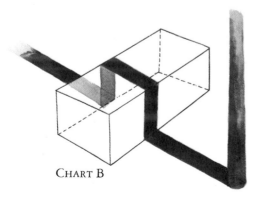

CHART B

Shadows describe form and are a vital part of landscapes as well as of still life pictures. Shadows can give an old building a sunny appearance and help bring out texture. Shadow patterns can enliven a picture and add interest and excitement. Add shadows last. Determine the light source and study the shapes over which the shadows fall. Shadows help to design a picture.

Review lessons 5 and 10. You learned that the side away from the light had a shadow that gave the subject form, substance, and dimension. It is called the form shadow. Study the house in Illustration 1 at the beginning of this lesson. Every part away from the light source is in shadow. The form shadow is on the object itself and gives form and depth to the shape. It gives roundness to a ball or to a cup.

In addition to the form shadow, there is also a cast shadow. The cast shadow may fall on the object itself, on the ground, or on some other object. In Illustration 2, the form shadows have been left off, and we see only the cast shadows. They are under the eaves of the roof, under the porch, on the ground, and there is a cast shadow of the little building on the side of the house. If form shadows were also included, the cast shadows would come out darker because you would be using color on dry pigment which makes a darker hue. Shadow colors should always be transparent, and you should be able to see back into them. Accomplish this by painting back into the shadows after they are dry. Basically the shadow color is cool, but it is influenced by the time of day, the sky, and the subject color over which the shadow falls. Play warm against cool and cool against warm to make a shadow read.

In Illustration 3, pick out the form shadows. Then the cast shadows. Notice how the trees shape the roof of the house. Students always have some problems with shadows and ask questions about them. For instance, how wide should a cast shadow of a tree be? In Chart A, look at the circle on the ground that represents the circumference of the tree in perspective. The shadow comes out from the sides of the circle. Use this guide to determine the width of a shadow. The position of the sun, of course, determines the length of the shadows, creating very long ones in the early morning and late afternoon.

Let us now examine the cast shadow that falls on the ground and on the objects in its pathway. The shape of the cast shadow is controlled by the surface on which it falls. In Chart B, you will see that the cast shadow of the vertical line falls along the ground, up and across the block, and down on the other side. Chart C shows the same process as the shadow of the tree falls along the ground, down the bank, across the road, down into the ruts, and up on the other side. Shadows falling over rocks assume the shape of the rocks. Shadows become progressively lighter the farther away they are from the source because there is more light to dissipate them.

Lesson 17

Reflections in Still and Moving Water

There is no elevator to successful watercolor painting where you can get on and ride up. It is a steep climb every rocky step of the way.

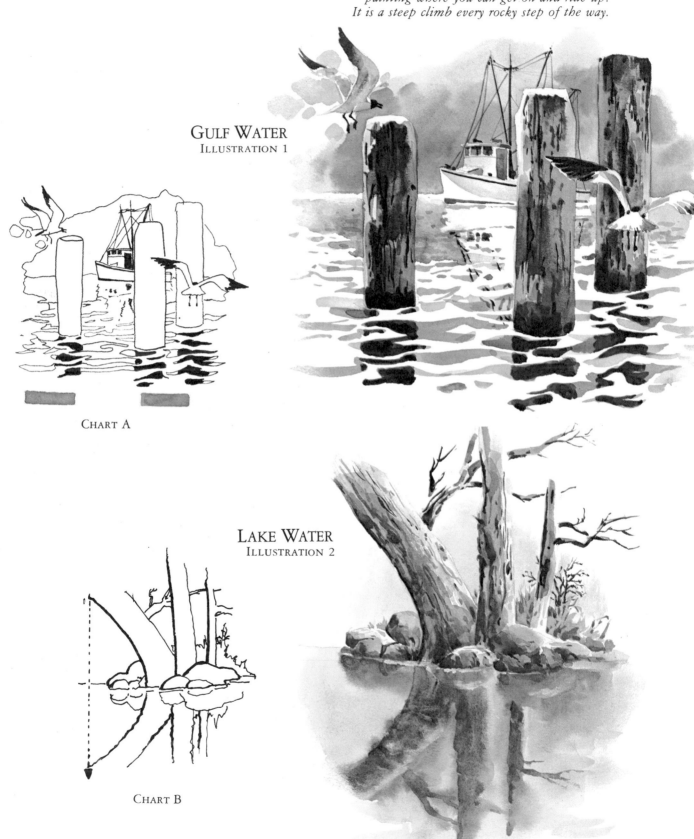

GULF WATER
ILLUSTRATION 1

CHART A

LAKE WATER
ILLUSTRATION 2

CHART B

A reflection is a return of light from a surface. It is an image given back by a mirror. Still water and even moving water in certain instances will reflect the objects above.

Illustration 1 of this lesson is a painting of gulf water with moving waves. Note how the water reflects the posts or piles above. Study the outline drawing in Chart A. Interesting shapes are sketched in, leaving the negative space to be the white waves. Why are the waves white? They glisten because the surface angle is different and reflects the light source. Note that no two shapes are alike. The dark, painted parts in the outline drawing are the reflection of the vertical posts. Take special note of the fact that the reflection is not in the white waves but in the blue water.

Now, study this in the painting. Ignore the distant boat for the time being and try your hand at painting the posts and blue, interesting shapes, leaving also varied shapes for the white waves. When this is dry, paint in the darker reflections of the piles, only in the blue water.

How did it turn out? Practice until it becomes easy, then complete the entire picture, putting in the boat and painting behind the sea gull. Last of all add the darks on the birds and the boat. The blue sky ties it all together.

Calm water presents a different situation. Study Chart B. From the edge of the left tree in oblique, drop a plumb line down into the water for the return of the reflection to its proper place. The angle of reflection in calm water is a mirror image of the reflected object. It is as if the group of trees just flipped over into the water. Reflections in calm water are painted down, and they are the same color and shape as the object above. There can be a little distortion by the surface ripples.

Try Illustration 2. Paint it several times, and then try some reflections of your own choosing. How about trying a post reflected in a mudpuddle?

Lesson 18

Part Three

Elements of Design
Line & Form

Lines in Design

Good watercolors are the result of good painting habits that grow, as the acorn into the tree or brook into the river.

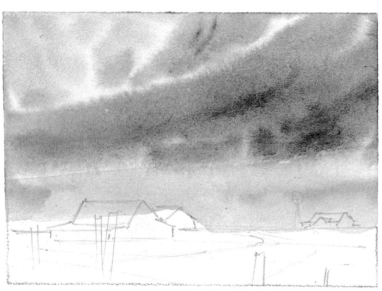

ILLUSTRATION 1

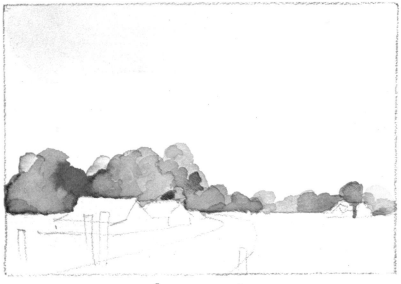

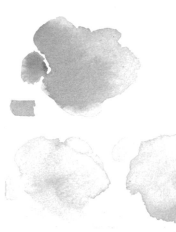

CHART A

ILLUSTRATION 2

One single line has two dimensions, length and breadth. Notice the lines about you, flowing, curved, rounded, wide, narrow, broken, and arched. A predominance of horizontal lines tends to make the viewer feel quiet and at peace. A strong oblique line in a picture creates excitement, unrest, interest. For instance, the lines in a steeple or gable may stand out as the strongest area in a picture, so be careful how you use them. Long straight lines in a picture do not usually create good design.

Lines, in some manner, should lead into or point towards the center of interest, and you should avoid having them lead out of the picture. Lines have a tendency to divide, which may be good or bad, depending on the use you make of them. Even more powerful are combinations of some of these lines, such as the sides of a road, the banks of a stream, the two sides of a tree, or a post. Parallel lines converge as they recede into the distance, giving dimension and depth to the picture.

Before you begin to paint, study the lines in the picture in Illustration 4. Note the oblique clouds. It is not a calm day, a storm is brewing. Excitement is there. See how the parallel sides of the road converge as they recede behind the barn. Notice the windmill, the dead tree, the posts, the grass. After you have studied the picture, take a careful look at the color examples in Chart A. In Chart B you'll see posts are made like trees with light areas and color and are not solid black sticks.

The only verbal help I'm going to give you in this lesson has to do with painting the sky. Review lesson 14. Wet your paper and allow the liquid colors to blend. Lead into the picture and out with strong color. Create oblique lines in clouds for design and action. Use enough pigment to hold, but stir the color so it will be transparent. Paint your picture.

Lesson 19

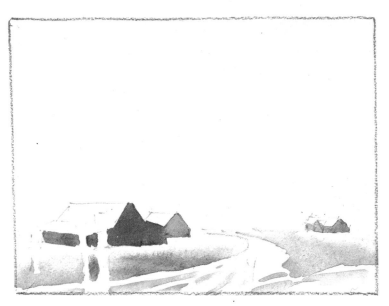

ILLUSTRATION 3

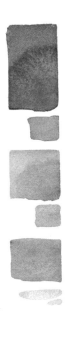

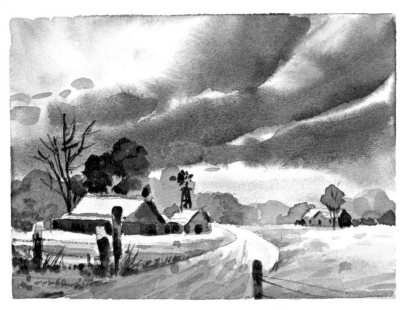

ILLUSTRATION 4

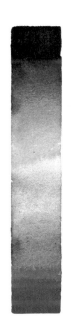

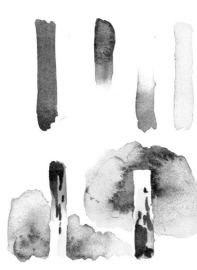

CHART B

Critique

Study your picture at a distance. Do you have soft clouds in the sky? Do your cloud shapes run parallel with the top of the paper? They should be oblique.

Look all over your picture. Do you have any hard edges? Did you say, "no"? How about the houses, barns, windmills? Manmade objects most often have hard edges.

Which are the shadow sides of your barns and houses. Blue should have been painted over the local color on the shadow side to give form.

Did you outline your road? No road should be outlined. Is it made up of warm colors in the foreground and does it fade to white in the distance?

Is there a space of white paper between the barn and the soft edges of the grass?

Do you have many beautiful colors in the background trees?

Did your road cut your picture into two equal parts? Study the example.

Study your branches on the trees and the varied way the spaces are broken.

Are your posts straight black marks, or do they have interesting shapes, highlights, and beautiful color?

Are your contour lines going down to the road? Contour lines will be the subject of our next lesson.

In your paintings, try to place one object in front of or overlap another object. It gives dimension or depth. If there is nothing there when painting on location, invent something.

In the foreground, you can see individual weeds. In the background they blend into a color with no detail.

Contour Lines

Failure is only for those who quit.

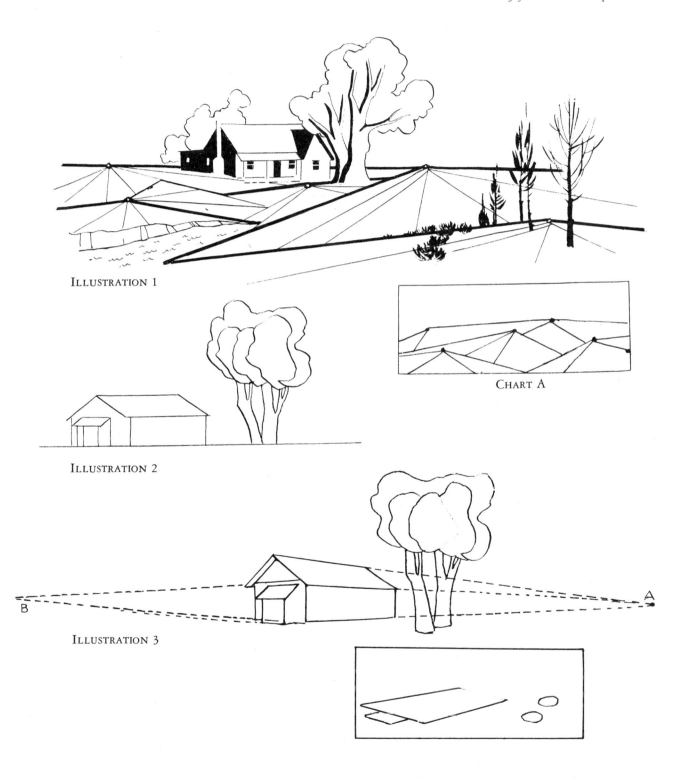

ILLUSTRATION 1

ILLUSTRATION 2

CHART A

ILLUSTRATION 3

Look out the window at the ground and you will see that it is not perfectly level, even in sections that are relatively flat. Therefore the ground area in a picture should not be painted parallel with the bottom of the paper. Contour lines denote the shape and form of the ground area in a picture.

Illustration 2 is an example of what not to do. The house and the tree look as if they were balanced on a string. There is no depth or dimension.

In Illustration 3 the house seems to occupy space. The floor plan is drawn as viewed from an airplane looking down on it. One tree fills space behind the other tree. In the house above the floor plan, vertical lines were drawn and the lines denoting the right sides of the house, including the roof, all go to vanishing point A. The left sides, go to vanishing point B at the left. This concept gives dimension. That is, some things seem to stand behind others, and so you bring depth and distance to a flat piece of paper.

We now want to learn to create distance in ground areas. Chart A shows five dots placed at random with straight lines drawn out in all directions. In the picture space around the house in Illustration 1, I've placed five dots at random and drawn lines from these dots in all directions as in Chart A. The problem now is to choose which of the lines to select to best represent the contour of the land, showing rolling hills and knolls. In Illustration 1, I have used a heavy line to show the particular contour lines I might choose to denote the shape and form of the ground. Look at it carefully and note how much distance is created by the mounds. You would not have this distance if you painted the ground parallel with the bottom edge of the paper. You might choose different lines and so have a different land area.

Lesson 20

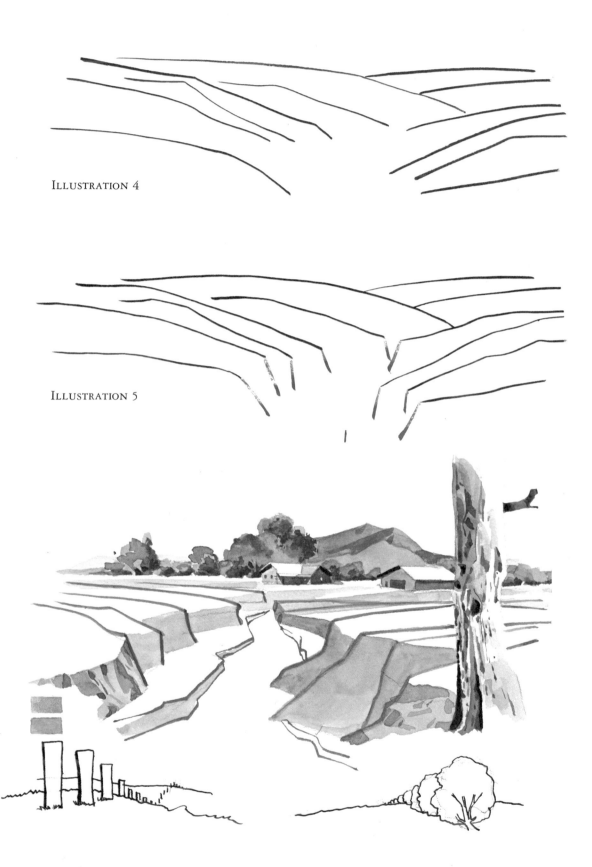

ILLUSTRATION 4

ILLUSTRATION 5

In Illustration 4, the contour lines were drawn at random. Be careful that you do not draw a series of lines all slanting in the same general direction with similar shapes. No two lines should be alike. Try this, and see how hard it is to make different types of lines.

Illustration 5 shows random lines with a down slope toward the center to denote depth. The bottom Illustration shows a gully with the contour lines connected, creating interesting shapes at the top and bottom. Study them carefully to see that no two of them are alike. Paint a bush so you see only half of it or a fourth of it above the contour lines and it appears to grow on the incline behind the slope made by the contour line.

Practice making contour lines as shown in all these examples and then try painting the picture of the gully.

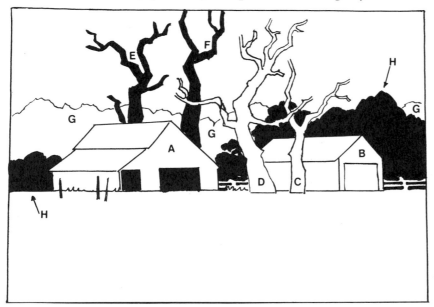

ILLUSTRATION 1
 On a sheet of paper list all the things you can find that are wrong in the above picture.

 Compare your list with the list below to see what is wrong in the first illustration.

 The horizon line divides the picture into two equal parts.
 Building, fences, trees, and shrubs are strung out as if they all rested on the horizon line.
 The foreground is bare.

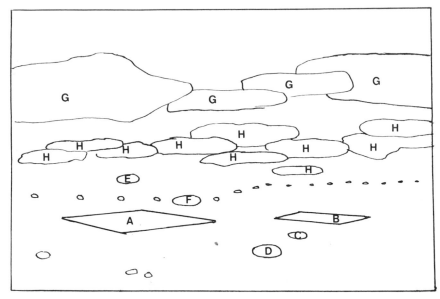

ILLUSTRATION 2

This is a plot plan for the proper location of objects in Illustration 1. Match A in Illustration 2 with A in Illustration 1 and so on for BCDEFGH. Notice the ground space.

ILLUSTRATION 3

This picture shows how the buildings and trees would look if they were drawn according to the plot plan in Illustration 2. Two important things in dimension are ground space and size, and of these, ground space is more important. Where an object is placed on the ground in relation to other objects gives it the illusion of distance.

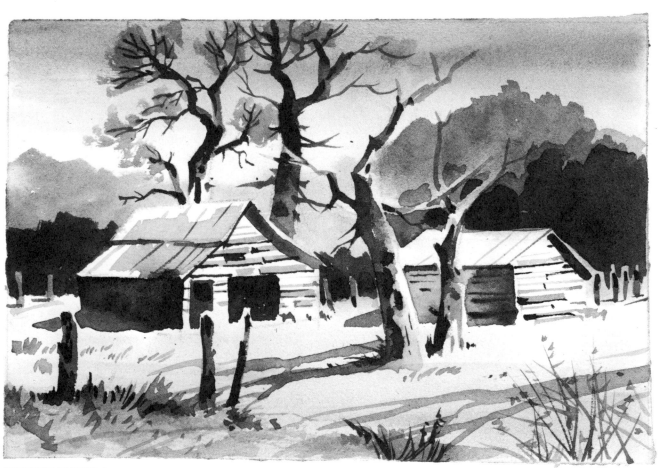

ILLUSTRATION 4

 Complete Illustration 4, first in the gray tones and then in a limited palette of your choosing. Note the foreground shadows of objects that are outside the picture.

 Get out some of your old pictures you have painted. Do you have overlapping objects, or are you placing everything on one straight line? Create some designs of your own and give them dimension by paying special attention to the placement of objects on the ground.

Rocks—
Form and Cast Shadows

Rocks are easy if you paint shapes and shadows with top light.

CHART A

CHART B

CHART C

CHART D

CHART E

ILLUSTRATION 1

ILLUSTRATION 2

ILLUSTRATION 3

Let's talk about painting rocks, following the steps as demonstrated by the charts on the opposite page.

Take a shoe box (Chart A).

Step on it so it has a varied, oblique shape and paint the form shadows (Chart B).

Make some form shadows darker than others because they are further from the light source (Chart C).

Paint on the cast shadows where one rock cuts off the light and casts its shape as a shadow on another rock. There is a cast shadow on the ground (Chart D).

Break up patterns and paint textures, darkening the deep areas between some of the rocks (Chart E).

There are many interesting ways of making rocks. Paint an interesting, varied shape of beautiful color. Use all you have learned about interlocking colors and dropping in jewels. (Illustration 1). Let this dry. Paint in the form shadows. Deepen some and paint in cast shadows and texture. (Illustration 2).

Rocks in moving water are usually rounded as in Illustration 3. Paint in the shadow side and leave the other side light by painting behind the shape with the shadow side of the next rock. Notice how the water shapes the tops of the rocks, leaving a highlight. Texture can be applied with a dry brush on rough paper. Fill the brush with rather dry pigment, place the brush on the paper and take off like an airplane. In this manner, the paint touches only the tops of the bumps in the paper and a beautiful texture is created as in Illustration 4 on the next page.

Illustration 5 shows an entirely different way of making rocks. Paint an interesting shape of not too liquid pigment and of varied, interlocking colors. Wait a bit until the paint will scrape off and still leave a residue of color. Use a spatula, old credit card, or palette knife, and with a strong motion, scrape the light side of the rocks. Cracks and crevices between rocks may be darkened.

Lesson 21

ILLUSTRATION 4

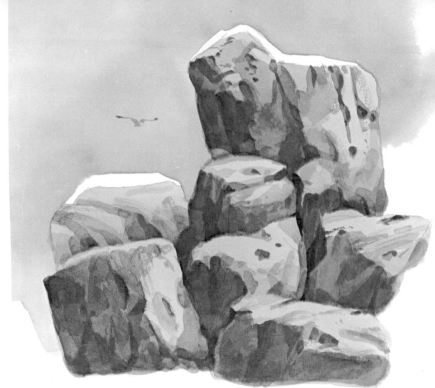

ILLUSTRATION 6

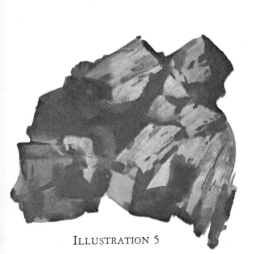

ILLUSTRATION 5

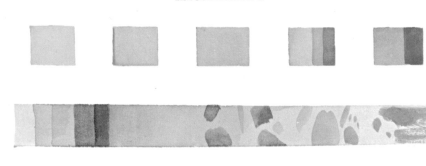

CHART F

CHART G

CHART H

Remember Lesson 12 in which we painted roots in shadow at the foot of a tree? We put tissue paper over a photograph and darkened in the deep shadow shapes back of the roots. You can do that same thing with a photograph of big rocks. Place a tissue paper over Illustration 6 and darken the shadow side of the rocks with a pencil. You will have a form shadow picture like Chart F. Study these shadow forms.

Now, paint some of your own rocks as follows:

Paint shadow areas as in Chart F. Let it dry.

Paint on a local color as in Chart G. Let it dry.

Paint a blue shadow area as in Chart H. Ultramarine with a little touch of umber will give you basically a good shadow color as long as it is transparent. Remember, you should always be able to see back into a shadow. Paint the ultramarine on and lose the outer edge. Paint in texture.

Notice, in Illustration 6; I put the sky in leaving a highlight on top, giving me more dimension. You can redesign the rock by whatever is back of it, leaving more highlight.

Each time you complete some rocks, put them up, sit back and critique them. Rocks have a way of looking more like rocks if you view them from a distance. Do your rocks say, ''Hard, sharp, rough''? Do not expect to be successful the first few times, but don't give up. Rocks are easy and a beautiful part of many pictures. Besides, they are fun.

Practice What You Have Learned

*Practice makes a perfect mess if you keep
making the same old mistakes over and over.*

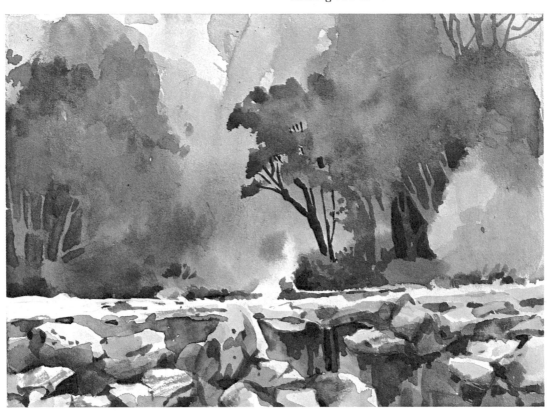

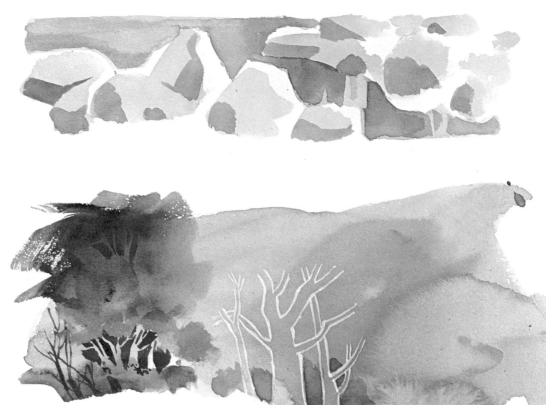

Lesson 22

This is a quickie, but it involves most of the guidelines we have been studying. Paint a picture with rocks, trees, water and sky. Think! Plan! Then proceed with knowledge and understanding.

Plan before you paint. What is the subject matter in the illustration? Where should the whites and lights meet the darks to create the eye of the picture? What limited palette will you use? What are the shapes you will create? Will your trees be little lady trees or a big expanse of branches? Where are the size varieties? When will you paint behind? How do you make the rocks and leave highlights? How do you begin?

Complete your picture after careful planning.

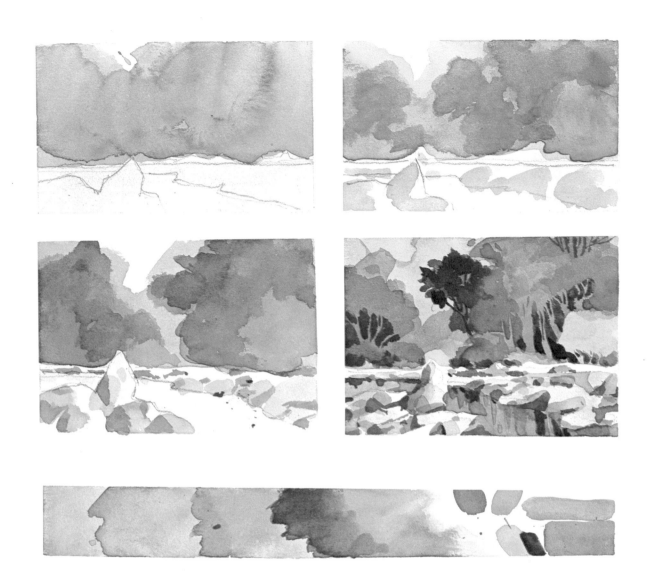

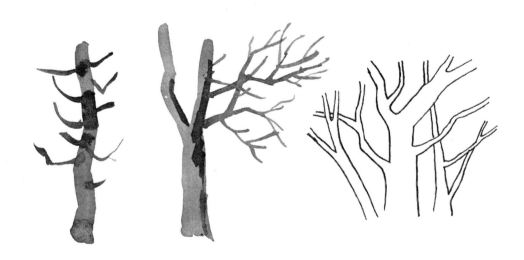

Critique

Put your picture up and study it with a trained eye.

Review means to look again. Let us be very honest as we conduct this self appraisal and see if we have actually made some of the principles ours.

Did you wet your paper before you began? How about your color? Does it sing? Is it flat? Is it transparent? Did you drop in jewels? Is it fresh or overworked?

Look next at your shapes. Are most of your rock shapes alike? Come on now! Students find it very difficult not to make these rocks alike. How about spaces and shapes between tree trunks? Are they varied, interesting, and convincing? Do you have a negative tree and a positive tree? Do the shapes of your trees look like foliage and the shapes of your rocks look like hard, heavy rocks? How about the form shadows and the cast shadows on the rocks? What can you say about the rock crevices and the texture? Did you make rocks all the way across the bottom? Study the illustration and note the break for better design and for a way into the picture. Does the water shape the tops of the rocks and leave a highlight?

Where is the eye of the picture? Do you have a light and a dark and some detail to bring the eye back into the picture?

How about your reflections? Were they painted down? Do they pick up the shape and color of what is being reflected?

Is the bottom of your picture too light? If it is, it will draw the eye to the edge instead of to the place of interest. With a large brush lightly wet the bottom of the paper for about three inches or so and, using a neutral color from your limited palette, darken the bottom of the page slightly. Do not paint up as far as the wet area or you will have a hard line. Stop well below the water line and let it bleed. Do not make it a straight line at the top, but vary the shape. This should read as a slight shadow area that will not draw the eye out of the picture.

Procedures Vary, Design Elements Remain Unchanged

Your mistakes and failures all may be listed under one heading — experience.

CHART A

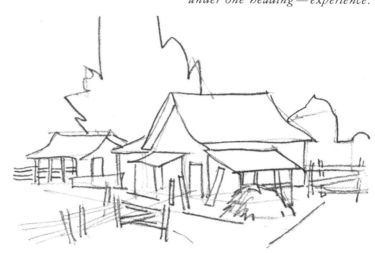

ILLUSTRATION 1

ILLUSTRATION 2

There are several ways of doing almost everything in this life. Watercolor is no exception. The master watercolorist experiments with all the ways he can find, and then he chooses his own method or methods that best express his feelings and message. Procedures may change from age to age and from artist to artist, but every good picture will hold true to the elements of design.

This lesson is a different type of watercolor, and it is accomplished in a different manner, but the basic elements of design remain unchanged. Let's study these design elements in the picture. Begin by looking at Illustration 4 of this lesson.

COLOR AND VALUE. Well, here they run riot. The warm colors are on the sun side and the cool colors on the shady side. The colors are transparent. The values are true, and even though a contrasting palette was chosen, the values recede to achieve depth and dimension.

SPACES AND SHAPES. The shapes are painted with a positive statement and the important whites are untouched. Note that there are no two shapes alike, and the shapes of the spaces are also interesting and varied. Without these two important elements this painting would be destroyed. Note how the bushes and the branches on the trees break up the spaces into further interesting areas.

LINE AND FORM. Note the converging lines as they recede. Look for all the different types of lines, long lines, short lines, broken lines, horizontals, verticals, and obliques. Contour lines! Form and cast shadows!

TEXTURE. Texture is the last of the elements of design and will be the topic we shall study next. Look about the illustration carefully to see how the texture brings life to design.

How do you paint a picture like this? Follow the illustrations, and they will tell the story.

ILLUSTRATION 1. Your drawing may need to be a bit more complete at the beginning with this procedure.

Lesson 23

CHART B ILLUSTRATION 3

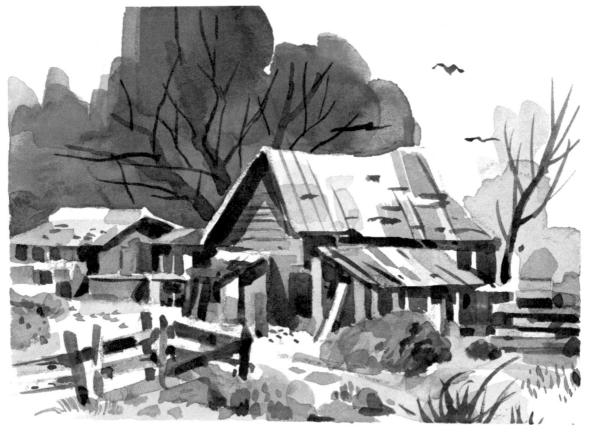

ILLUSTRATION 4

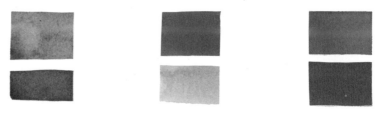

ILLUSTRATION 2. Do not wet your paper first. Apply liquid pigment, well stirred, directly on the paper. Make a clean, concise statement. Vary color values, shapes, sizes, and pay special attention to the whites. Study the predominately cool colors used in Chart A.

ILLUSTRATION 3. Note the warm colors in Chart B. Remember that contrast calls attention to itself, so your darkest values and lightest values should be placed together only at the center of interest in the picture. Abstract forms are pulled together, and warm is played against cool and cool against warm.

ILLUSTRATION 4. The darks and textures are added. Set up your picture many times during the painting and study it. You can not really tell what a picture looks like up close. Critique your picture and make changes as you proceed. Study your shapes, spaces, colors, values, lines, and form as you paint, making corrections as you go. Make the eye of the picture read with contrasts and detail.

Perhaps you like this style. Try some more pictures like it, but plan them around the elements of design.

104

Part Four

Element
of Design
Texture

Serendipity!
Texture at Last!

One emotional factor that hinders success is the fear of making mistakes.

ILLUSTRATION 1

CHART A

CHART B

Legend has it that when the princes of Serendip went on a journey, something unexpected always happened, and they found valuable things as a surprise. It is a serendipity to come to this last element of design and get to put in texture, details, and darks. Things happen that are a sheer delight. The picture begins to sing. You wanted to put texture in first, but it doesn't work until you have done all the things you've been studying to build up the picture.

Texture is the quality of the surface, rough, smooth, dull, reflecting. It is an identifying quality telling you whether you are looking at a rock or a piece of silk cloth. It is the character of substance, the visual or tactile surface characteristics and appearances. It spells out the difference between a tennis ball and a ball of yarn. It is the quality that appeals to sight and touch. It is this ability to differentiate between the textures of different objects in a picture that makes a painting come to life. The far away objects lose their textural qualities because of distance, but this fact only makes the texture on nearby objects more powerful.

There are many ways to achieve texture. You can spatter on color, or you can scrape painted surfaces with a spatula or palette knife before they are dry. Be sure your scrapes have variety in shapes. You can use a razor blade and just barely scrape the color from the tops of the bumps in the paper and achieve a glistening surface. Or you can paint a second or third time into an area and add texture.

Study Illustration 1 on the opposite page. The background trees have almost no texture because of distance, but look at the texture on the foreground trees. It is not put on in one step, but the tree is built up as described in Lessons 2 and 4, beginning with the first blue shapes. Review Lessons 2 and 4.

How do you begin? Start with the sky (Chart A). Build up the tree and use the background trees to help shape the big tree. Study each chart and pay special attention to Chart B, which shows you that texture is made by painting positive shapes to form negative spaces.

Paint your picture carefully, planning at every step and giving yourself a critique at every stage. You know the questions to ask and how to make the corrections.

Lesson 24

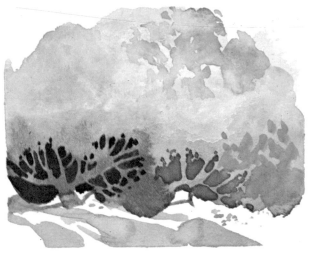

CHART C

CHART E

CHART F

CHART G

CHART H

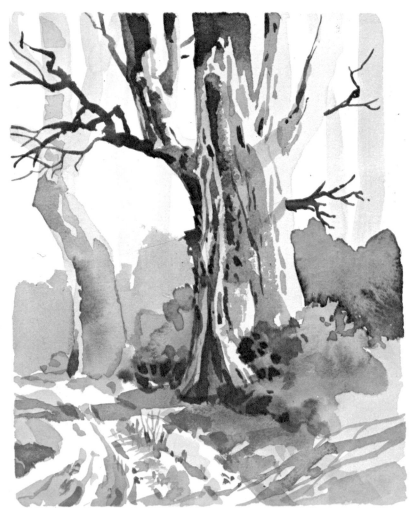

CHART D

CHART I

Critique

Your picture should be completed and you probably will come out with one you want to frame so apply these questions with care.

To begin with, did you wet your paper? Do you have soft edges?

Did you allow ample drying time before you went back into your underpainting to build up your picture?

Is the road white at the back curve and warm in front as it should be? Is it solid? It should not be. It should be made up of interesting shapes.

Does the foliage begin far back in the distance and come closer and closer and become a warm green in front?

Do the tree trunks bend and have interesting shapes and exciting spaces between them, or do they stand like tin soldiers in a row?

Train your eye to observe value and color.

Did you get the rough feeling of the trunk in your painting? If not, why not? Did you build it up as you did in Lesson 2? Are your darks interesting and convincing?

Is the texture on the road different from the texture on the trees?

Do you have grass or sticks?

Can you see into the shadows or do they look like oil spilled on the road?

A tree, as it is silhouetted against the sky, appears darker at the top than at the bottom. Its base is usually darker than the ground. If you paint what you want to be a big tree, it does not appear big unless you have a small, thin tree near by to show the contrast.

Don't paint the ground flat, put in contour lines as in Lesson 20.

When you put in darks, do so by degrees so you have many value changes. Do not paint all darks into a dry area. Wet an area, put in darks, and then drop in some jewels. Let it run. It will make many interesting, beautiful shapes, values, and colors that you could not otherwise achieve.

Time and again I hear my students say, "I wanted to change that, but I was afraid..." Don't be afraid to fail. Go ahead, make the change, make a mistake. It is the creative failure that leads to success. A good artist is known by the number of his rejects. Some of the finest artists have more culls than anybody.

Too Little or Too Much

There is a fine line between doing too little and too much.

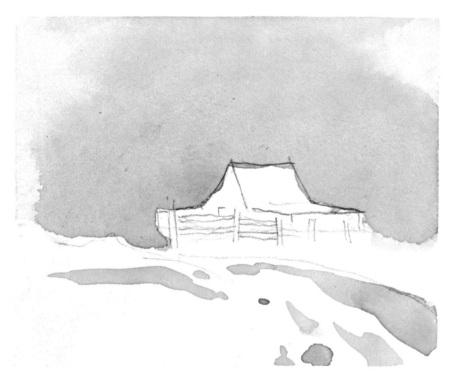

ILLUSTRATION 1

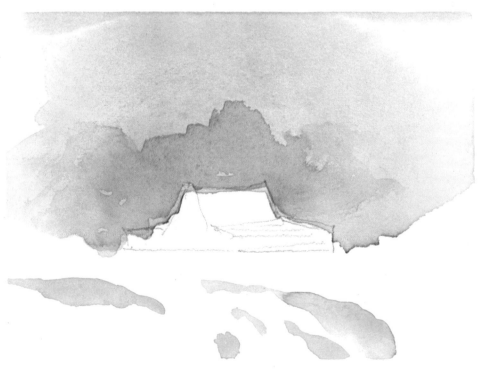

ILLUSTRATION 2

This is a lesson in restraint. Painting a subject need not be a complex project. To prove it, let's try the following steps.

ILLUSTRATION 1. Make a very simple sketch. Check that it does not divide the paper horizontally, vertically, or diagonally. Select your limited palette. Wet the paper and complete the sky wash and warm shapes in front to indicate the road. Do not outline the road. Let it dry.

ILLUSTRATION 2. Using receding colors paint in the background trees making interesting shapes. While this dries, study Charts A and B that show you how to make the fence. Note that it is not solid. The bush and tree behind shape the fence in places. Study Charts C and D to understand the texture on trees and to review the shapes of foliage and branches.

ILLUSTRATION 3. Paint in good shapes of the foliage using the process of building up transparent color over dry pigment as we have studied. No two shapes should be alike and they should overlap with convincing outer edges and holes in which to paint branches. While this dries, study Chart E to understand how the shadow sides of the barn shape the negative fence.

ILLUSTRATION 4. Build up texture and final values. Do not get excited at this point and negate all you have accomplished by overdoing it.

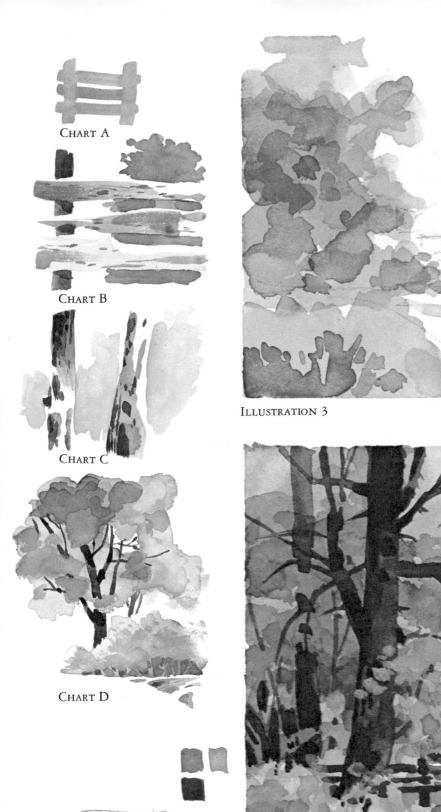

CHART A

CHART B

CHART C

CHART D

CHART E

ILLUSTRATION 3

ILLUSTRATION 4

Critique

Question yourself, following the usual steps about soft edges, color build up, and interesting shapes especially in the negative areas made by the tree branches. Do your trees say, *big trees?* By now you should have these questions well in mind. You should have stood back and critiqued your picture with questions many times during the painting and you should have made corrections step by step. This critique will emphasize texture.

In painting textures the student usually begins in an area and goes all the way across doing the same things, making the same shapes. This is monotonous, repetitious, and a case of doing too much. Study the example. The grass in front has detail at the left, but it is not repeated all the way to the road. It is suggested. That's enough. The grass on the right of the road has detail near the fence and center of interest, but it is not repeated all the way to the edge of the painting. The trees are not solid, but are broken by foliage areas. The fence is partly negative and partly positive for variety. The foliage has detail near the center of interest, but does not repeat the process to the edge of the painting.

Note how little painting it takes to say, *roof.* The road is not solid. The picture was completed by adding values and not details.

Study your picture for these fine approaches to beauty. Do not do too much.

Perhaps you were afraid of the texture and did not go dark enough or put in enough value changes. Place the illustration beside your painting and check your values against those in the workbook. There is also such a thing as doing too little. Your picture will be uninteresting and will lack that quality that makes it sing.

There is a fine line between doing too little and too much.

Value Changes Create Texture

Happiness is painting a picture that opens the door of beauty for others.

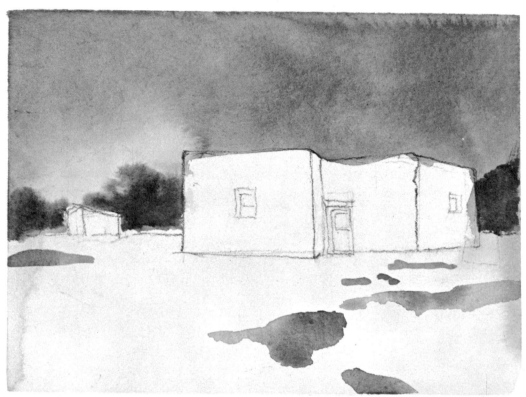

ILLUSTRATION 1

ILLUSTRATION 2

Again, let's follow a series of stages to make a painting that will futher exploit textural possibilities.

ILLUSTRATION 1. This underpainting presents a real test of your ability to paint interlocking colors in the sky and soft edges on the tree tops. Note that the trees also shape the side of the adobe and background building. Think it through step by step and then paint.

ILLUSTRATION 2. Keep the high cliff in the background by using a value and a color close to that of the sky. Start building rocks in the foreground. Let this step dry.

ILLUSTRATION 3. Carefully plan your procedure for adding the mountain, for painting behind the fence, for adding the tree trunks and branches, rocks, and modeling of the snow. Make the undulations in the snow by painting a soft blue shape on one edge and completely losing the outer edge. Do not make the doors and windows too big.

ILLUSTRATION 4. List the texture that you see in every area of the picture. Then try to paint it. The small flecks of white paint can be spattered on with a tooth brush or with a small brush. Do not overdo it.

Lesson 26

ILLUSTRATION 3

ILLUSTRATION 4

116

Critique

First, ask yourself the usual questions about shape, space, form, line, value, and color. Then proceed to the questions below concerning texture.

Is there some texture on the far mountains and trees that denote shadow and keeps it from being flat? These are subtle value changes.

What can you say about the texture on your adobe? Study again Illustrations 3 and 4.

Do the posts seem to have snow piled against them on one side because you placed them behind the contour line?

Did you remember the cast shadows? They are very important, especially in snow.

Did you place the dark value on the windows and doors?

Do you have darks in the background trees at the bottom to shape the snow and to make it look white? Darks next to the snow will always make it look whiter.

Did you darken the snow in the bottom front of the picture so the light will not draw the eye out of the center of interest?

What you do on one side, don't do on the other.

Did you use the adobe to shape the contour of the snow against the house?

Do you have interesting contour shapes of blue in the snow? Be sure you lost the outside edge softly and completely.

Are your weeds good shapes and not too many? Weeds and small bushes are like potato chips, you can't stop with one.

Is your falling snow convincing or did you overdo it?

Snow is fun. Try other snow pictures and apply this same critique to them.

What You See First You Paint Last

A beginning artist seldom makes the same mistake twice, usually it's ten or twenty times.

Look at the Illustration on the opposite page. What are the first things that impress you? Usually, it is the texture on the near trees, the boards in the bridge, and the lights on the grass and adobe. You see these first, but you should paint them last. What really holds the picture together and what affects you emotionally and artistically is the relationship of the colors and values. It is the tender nuance of color throughout the picture. Nuance is the subtle-distinction or variation of color and value. These color and value changes are actually the true work of painting a picture. You must build it up step by step. It begins with the first planning stages.

Study carefully the steps in the buildup.

Illustration 1 shows that the drawing is more complete than usual because you are going to paint in your shadows first.

Illustration 2 shows in detail all the shadow areas. Note the shadow on the horizontal rails of the bridge. Study and paint each shadow. Let it dry.

In Illustration 3 the sky and the local color on the adobe, the local color on the bridge, the foliage, and the beginning of the ground buildup are painted. Do not wet your paper first, but keep your pigment juicy and carry water in your brush. This illustration shows only the things you will be doing in this step. Of course you will be painting yours over the shadows you have already painted.

Lesson 27

ILLUSTRATION 1

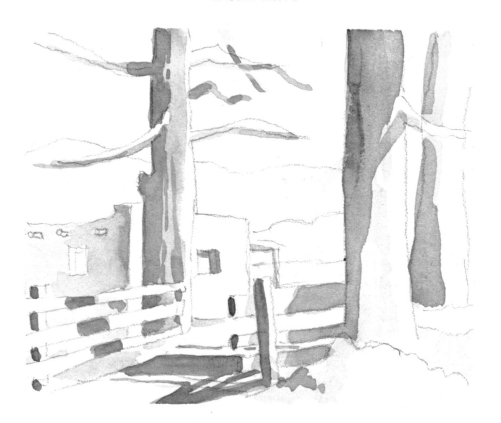

ILLUSTRATION 2

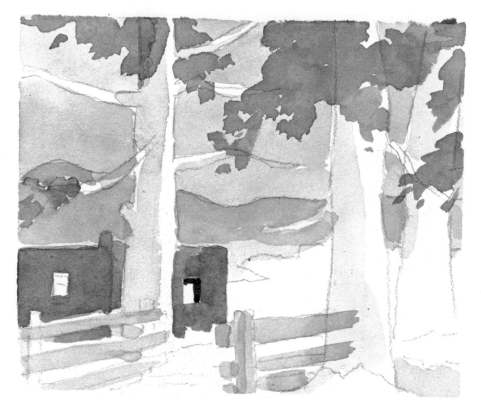

ILLUSTRATION 3

Illustration 4 shows only the steps you will take this time. It is actually painted over all you have already done. Each step must dry before you add another. Here you are building up colors and values. Study Chart A to see more clearly the value changes and texture on the adobe. Each step adds something to the value build-up on the trunks of the trees. Study Chart D to better understand the branches. Do not divide the bottom of the tree into two legs as in Chart E. If you put shoes on them, they might walk off.

Be sure you put your picture up and stand away and look at it before you complete your texture. You know the questions to ask. You know how to correct your mistakes.

Study Chart C to learn how to paint the texture on the bridge. Have a ball! Make your picture sing. Do those things you wanted to do first. Paint in texture. But beware! Don't ruin your picture at this point by covering up all your whites and lights.

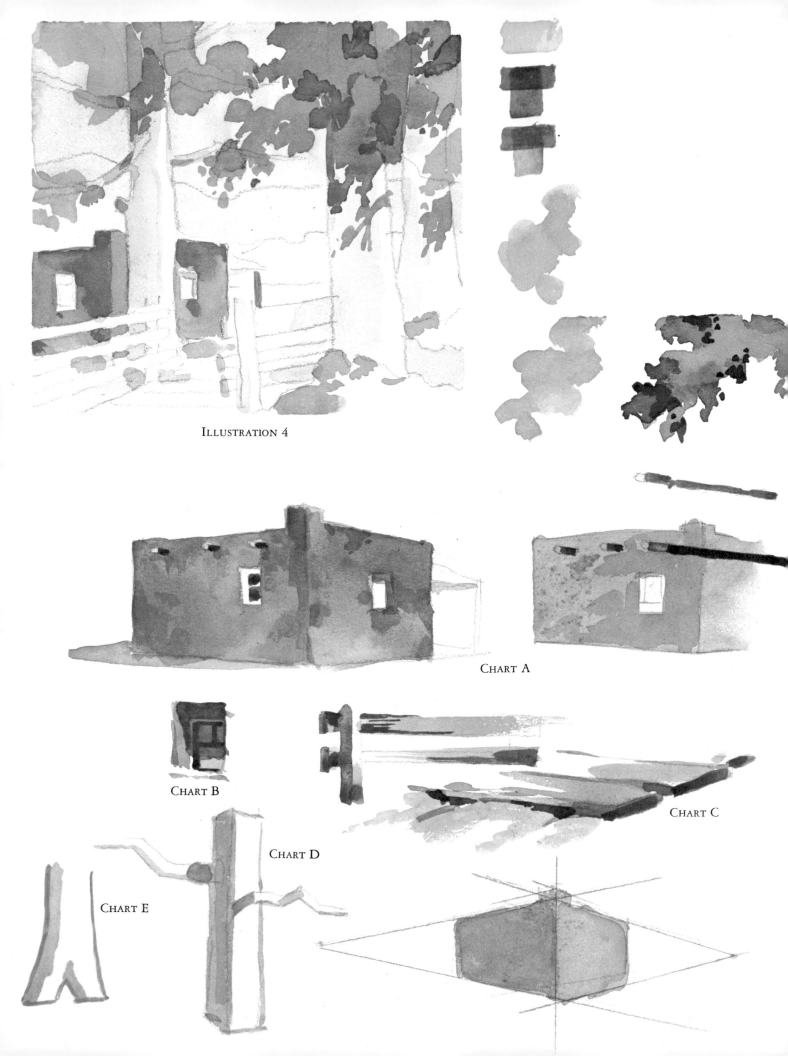

ILLUSTRATION 4

CHART A

CHART B

CHART C

CHART D

CHART E

Critique

Keep the workbook illustration in front of you while you ask yourself these questions and study your painting.

Is your painting transparent? Does it sparkle?

Are your boards in the bridge in perspective?

Are your trees lady trees or big bold individual trees with branches that reach far out and give shade to bless all who travel under them?

Do you have significant whites? Are the whites in the bridge, trees, and grass interesting shapes?

Is your bridge solid?

Are your tree trunks black and solid or do you have beautiful colors and values and texture?

Are the warm colors in the foreground and the cool colors in the background? Can you see far into the distance?

Do not be discouraged if this painting is not all you expected. Try it again and again. It contains most of the things we have studied throughout these lessons as well as some new procedures.

Did you use the branches for design to break up space into varied shapes? Did you put in dimension by having some branches cross over others? Did you paint darks in the trunks where they turn because the light falls on them differently at turning points?

Another Chance

Do not wait for opportunity to knock on your door. Create your own second chance.

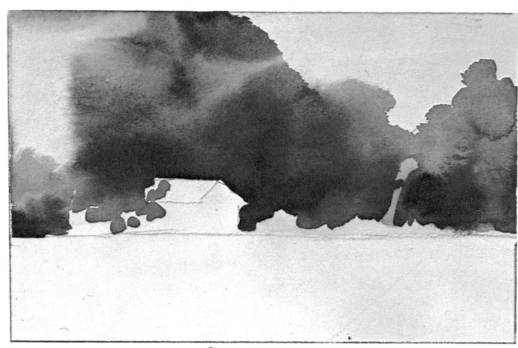

ILLUSTRATION 1

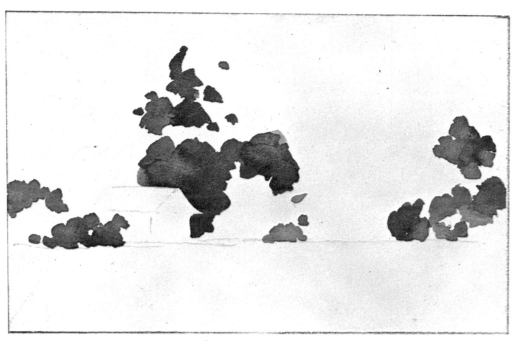

ILLUSTRATION 2

There is a compulsion in painting that makes the artist want to put on first a value in its final form. The beauty of all the color build up is lost. Start with an underpainting, juicy with soft edges. Paint transparent color over transparent color for rich, vibrating depth in values. If you come in too dark with hard edges, you have to live with it. But if you come in with medium values and soft edges, you can have another chance and another, and still another to build up to the value you want, always leaving some of the beauty and misty values with which you started.

A second chance! Is there anything an artist would rather have? Life is made up of creating your own opportunity. Success lies in the ability not to wait for opportunity to knock on the door but in having strength to make your own opportunity. Create for yourself a second chance by building up your color and values a step at a time. And when you use that precious second chance, don't blow it. If you are smart, you can build again with deeper values and soft edges and still have another chance.

Lesson 28

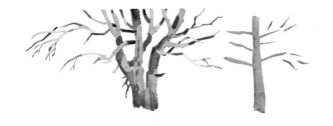

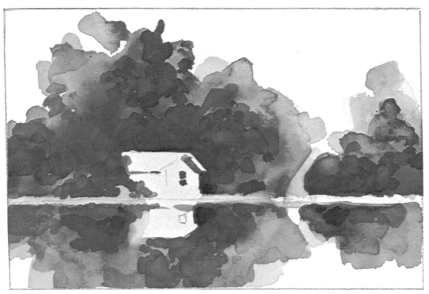

ILLUSTRATION 3

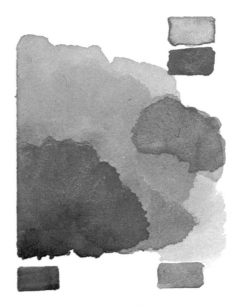

CHART A

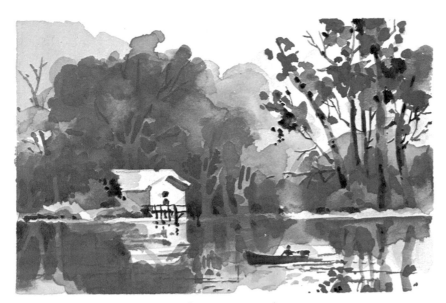

ILLUSTRATION 4

CHART B

126

This lesson is a review and a culmination of all you have studied in this workbook. Look back at the lessons suggested and reread the critiques before you begin to paint.

Paint Illustration 4 by following these steps:

Illustration 1 (At the beginning of this lesson) and Chart A
Review lessons 1, 3, 7, 8, 11, and 13.

Illustration 2
Review lessons 2, 5, and 10

Illustration 3
Review lesson 18

Chart B
Review lessons 7, 8, 9, and 11

Review the first part of this lesson before you begin. Create your second chance.

Study your picture when you have finished. Perhaps you are not satisfied, but have you made real progress?

Open your workbook to each of the critiques in the lessons listed for review and apply all those questions to your painting. What other questions do you know that you can ask that will help you see your picture in a different light? Have you gained knowledge that will help you correct your own painting errors?

Planning The Picture

There is no such thing as standing still in art. If you are not going places, you are sliding back.

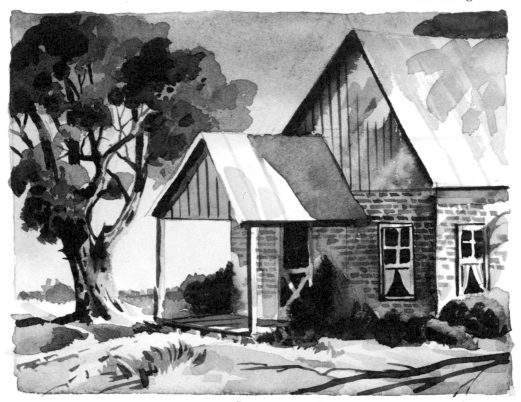

ILLUSTRATION 1

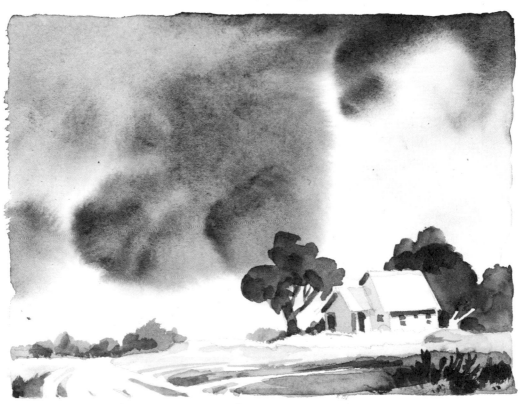

ILLUSTRATION 2

The first step in planning a picture is the thinking step. It is first and of foremost importance whether you are on location, working from a photograph, or supplying the subject matter out of your own imagination. What do you want to say in the picture? What is it that makes this subject matter so significant you want to share it? Make very certain that the viewer is not in doubt about what you are trying to say.

Look at the illustrations on pages 128 and 130 because they say it best. If the house is the important thing, as in Illustration 1, make it big and put your contrasts and detail at the center of interest. Suppose you happened on an old farmhouse at the bend of the road at sunset or as a storm was approaching. The impressive thing in the picture would be the sky. Then make a small foreground and house as in Illustration 2 and paint a large, dramatic sky and approaching storm clouds. If this is your choice, say it with flair. Perhaps the ground, the road, and the nearby weeds or even the tree are the things you want to call to the attention of the viewer. Go for a lot of ground with very little house and almost no sky as in Illustration 3, or feature the tree as in Illustration 4 with very little detail of any kind in the background.

The biggest problem is that you may try to say too much, and as is always the result, it is confusing. Take

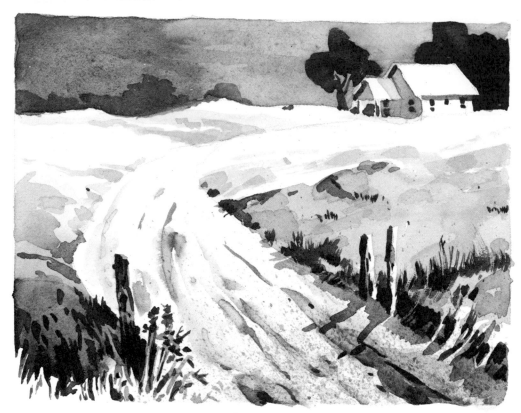

ILLUSTRATION 3

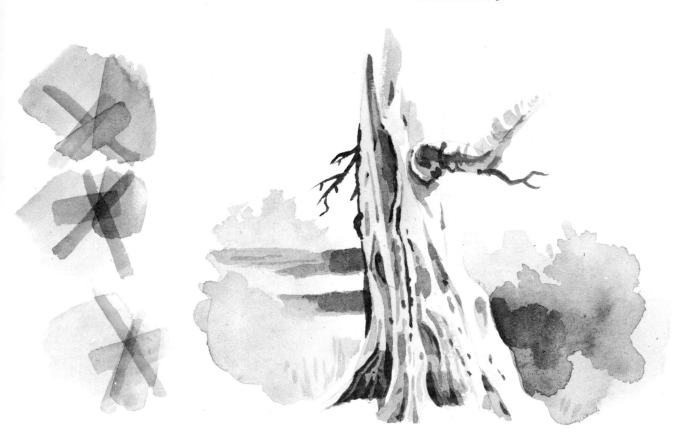

ILLUSTRATION 4

time. Think it through. Plan. Decide on the one thing you will say in the picture at hand and save the other thoughts for another picture. As we have already said, planning before painting is very important in watercolor. The first step is to decide *what* you want to say. The second step is to decide *how* you want to say it, planning your design pattern, darks and lights, and especially the whites, your limited palette, and painting procedures.

Find some of your old pictures you painted a long time ago. Look them over. Did you make just one statement? Is it clear what you wanted the viewer to see and feel? Is there an eye of the picture? Make yourself a small mat with an opening not larger than five by seven. Move this mat around over your picture, and you will see interesting things happen. A tree or a part of a house will be dramatized in the mat, making an entirely new approach. Turn your mat both horizontally and vertically. You will be challenged to try some of these views, and when you do paint them, you will see a great improvement in simplicity. You can enlarge an interesting sky or cut off a part of the house for a close look at detail.

Practice also making a verbalized statement of what you want to say in the picture. Putting thoughts into words makes for clarity, and anything that is fuzzy in your mind will be presented with confusion to the viewer. This skill does not come easy, but work at it. The quality of your paintings will improve and develop more appeal.

Borrow, Do Not Copy

The dictionary defines a student as an attentive and systematic observer. That is the eternal goal of the artist—to be a student of art and a student of nature.

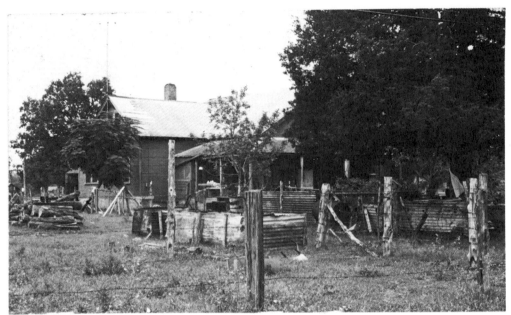

ILLUSTRATION 1

ILLUSTRATION 2

The story is told about three young, accomplished artists who set out to paint a certain landscape. They pledged themselves that they would not deviate a particle from the subject matter they were viewing. The result was three totally different pictures, as different as the personalities of the painters. I am sure you have been in art classes where fifteen or twenty people painted the same subject matter and listened to the same instructions, but each came out with a different picture. That is as it should be.

Don't copy pictures, not even your own photographs. Let your personality show through. If you want an exact duplicate of a scene, use a camera. It can do it easier and faster than you can. Rearrange, eliminate, add to, but don't copy.

Illustration 1 on the opposite page is a photograph. Do not just copy it as in Illustration 2. Borrow from it, but have a point of emphasis. Maintain the same flavor, but simplify the content and detail. Illustrations 3, 4, and 5 are suggested ways of painting a more meaningful picture, and they are all different. In Illustration 3, the house has

Lesson 30

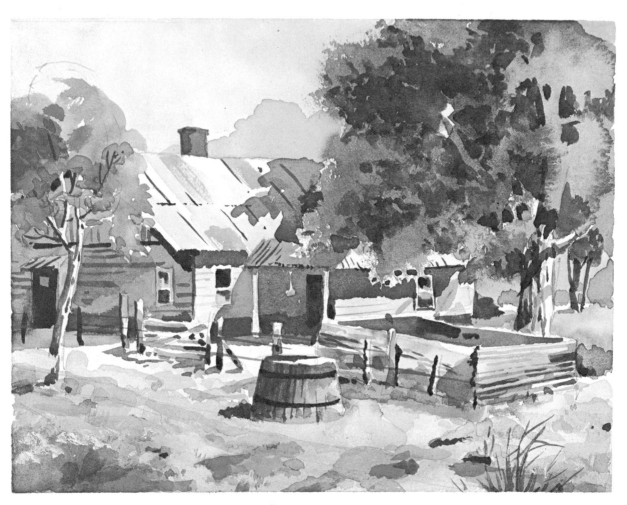

ILLUSTRATION 3

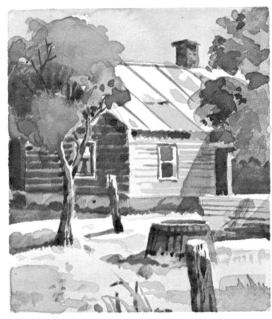

ILLUSTRATION 4

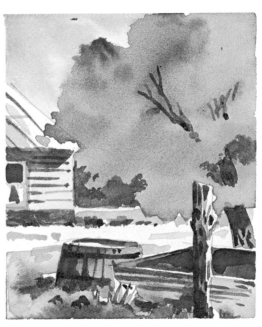

ILLUSTRATION 5

134

been enlarged and much of the junk has been left out. The little tree has taken on fall colors, and the sun and shadow play in the yard. Illustrations 4 and 5 are close ups of different objects. Can you make additional sketches from this same photograph?

Select several of your own photographs and make five or six different sketches from each one. In other words, practice changing your point of view and central thought by making several different sketches of the same scene. You cannot imagine the independence this exercise will give you. It is what you should do every time you approach a subject whether you are on location or working from a photograph.

Have you started your classified file of pictures, buildings, trees, and sketches? In lesson 13 we suggested you begin such a file so when you need a house of some kind, you can simply go to your file and find several from which to choose. You are wasting precious painting time if you have to search for every object you want. Borrow ideas for the shapes from many pictures and compose them into your own original work, following the laws of good design.

Finishing Your Picture

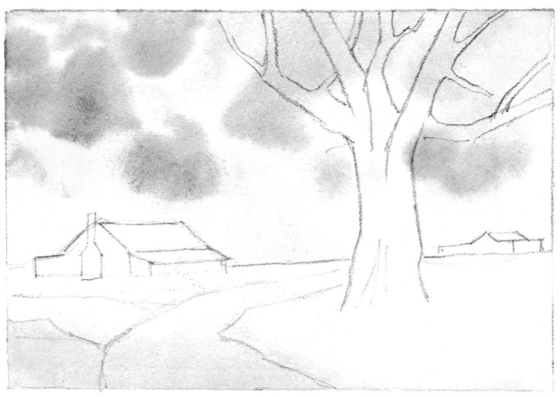

ILLUSTRATION 1

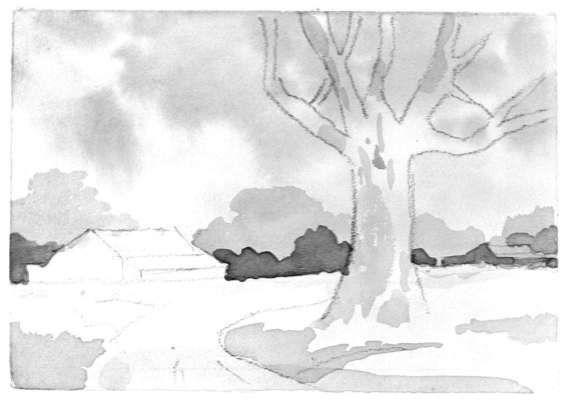

ILLUSTRATION 2

Let me say just a few words about completing your picture, based on the scene on the opposite page— then you are on your own.

After you have done a beautiful soft underpainting, *and* after you have added value upon value to build, *and* after you have added texture,—then you need to stand back and study your picture and add the final finishing touches. And I'm not talking about signing your name!

The final touches are those which give a sense of completion. Perhaps it is a very dark value added in the dark area to bring emphasis. It may be a dramatic shadow or a warm piece of grass. Perhaps you should paint a warm area beside a cool shape to make it more easily seen, or perhaps it's a cool beside a warm that you need. You paint values and push some things back and bring others forward.

Now, paint your picture . . .

Lesson 31

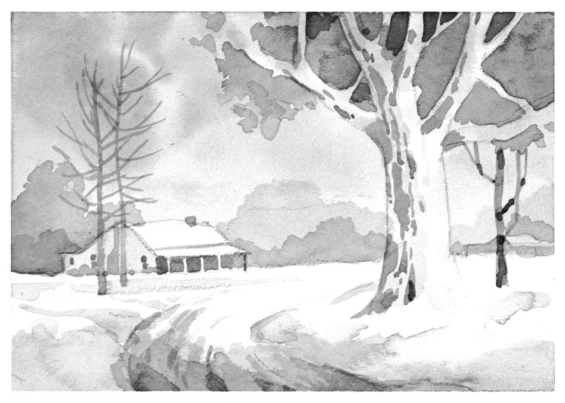

ILLUSTRATION 3

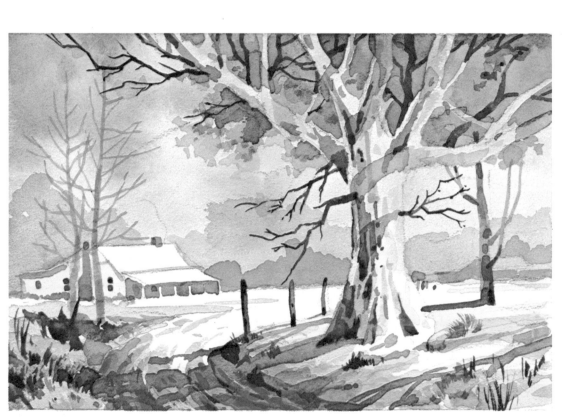

ILLUSTRATION 4

Critique

Do you have soft edges? Are your colors transparent with receding blues in the background and warm greens and browns in the foreground? Lessons 1 and 14.

Is your tree light, built up with interesting shapes and texture on the shadow side with interesting space division of the branches? Lesson 2.

Is the foliage made up of interlocking colors? Did you drop in jewels? Is the road outlined? Is there white at the bottom of the house in the background? Lessons 3 and 19.

Do you have form shadows and cast shadows on your background houses and foreground road? Lessons 5 and 17.

Do you have interesting shapes and spaces and dimensions? Lessons 7 and 10.

Did you paint the trees behind the house to shape the roof and paint behind the foreground grass? Lessons 8 and 11.

Do you have a positive tree and a negative tree? Do your background trees shape the sides of the big tree? Does the foliage shape the branches? Lesson 9.

Did you make contour lines leading to the road? Lesson 20.

Does your picture have perspective or is everything lined up on the horizon? Illustration 2, Lesson 20.

How about the texture on the tree and road? Lessons 24 and 25.

See how this one picture uses almost every topic we studied in the workbook. Most pictures will involve all the things we have learned. Let me repeat. This is a workbook. It is not to be read and put aside. Read it again and again for review. Use it often for reference.

Happy painting!

Applying the Art

Art is the conscious use of skill and creative imagination. The skill consists of educated experience in using the basic building blocks of design that we have been studying: color, value, shape, space, line, form, and texture. The creative imagination is the arrangement of these elements of design into a pleasing unity that can rightfully be called a work of art. There are some guidelines to assist us in beginning to explore and stimulate our creative imagination, but there is probably no limit to its expression. Some of the guidelines have already been mentioned.

Decide on the one subject matter of importance and say what you have to say so the viewer understands.

Plan an eye of the picture, the place to which the eye is pulled back away from the edges. Here are the greatest contrasts of light and dark values, the greatest detail, and the center of your message. This eye should never be in the dead center of the page or at the edges.

There should be unity—unity of color, values, and thought. A quiet pastoral scene would not read if it were painted on a vertical page with predominance of oblique lines, jagged rocks, and intense contrasts. You need a peaceful presentation, using horizontals, close values, and rolling ground spaces.

At the same time, there should be contrast. All horizontals call out for creation of interest by contrast, by using a few verticals. A picture made up of all light values loses its appeal.

There should be emphasis, especially at the eye of the picture to help the viewer understand. This is achieved by creating a predominance of color, line, and value.

There should be movement and rhythm, a flow of lines and color to lead somewhere, usually to the eye of the picture.

Involve your viewer, have something to stir the imagination.

Plan carefully the use of the art elements; shapes, spaces, lines, forms, colors, values, and textures.

On the following pages are a few completed pictures, and I'll call to your attention some of the guidelines for creative arrangement of the elements of art.

An enjoyable work of art is the sum of all its parts, planned and arranged by the creative imagination of the artist. The few pictures reproduced in this section allow the reader to view the application of the things he has been studying, and the comments, while they cannot divulge all the planning and knowledge needed to execute the work, will focus, with as little repetition as possible, on some of the more important design principles that bring to the pictures interest and unity. The readers will profit from further analyzing each picture on his own to better understand how all the elements of design work together. The questions from each critique in the book can be asked and answered in the study of these completed works.

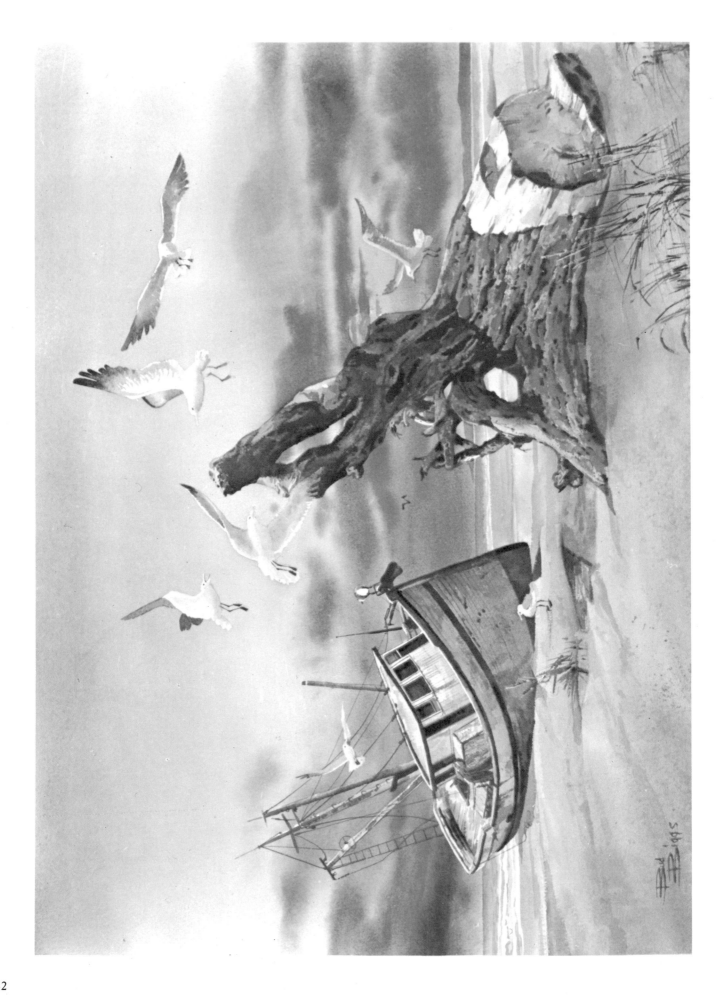

Beached

*Collection of Mr. and Mrs. Victor Ramsey,
Richardson, Texas.*

The low horizon creates a feeling of expanse and dramatizes the threatening clouds that unite with the other elements in the picture to tell the story. Unity is an intangible quality, depending on design to achieve proper relationship and visual cohesion. But unity also means telling one story and only one story. The association of ideas is important. In this picture, low key cool colors, the massive dead trunk, and the beached boat against the dark clouds say it all, and there is nothing that interrupts the story.

The grouping of the birds elevates the design, and the viewer is drawn into the picture by the pure color in the sky against the upflung white roots and boat.

There is a dominance of curves in the wings of the birds, the hull of the overturned boat, the clouds, upflung roots, and the waves. Curves lend grace and softness to design, but there is also strength in the decisive strokes, enhanced by the simplicity of the broadly painted areas. Without conflict there is no drama. Here, conflict is dramatized by the obliques of the hull of the ship and the whole movement of the trunk, positioned in the eye of the picture.

144

Mexican Market

Collection of Mrs. Doris Chalk Cole,
Big Springs, Texas

In painting from life, search for the total mood, not an exact reproduction of what you see. The geometric shapes of rectangles in this picture are obvious and dominant, but these shapes twist and turn so no two of them are alike. Variety is achieved by position, color, value, and size, holding the interest and keeping the eye moving from one part of the picture to the other.

The very short foreground brings the viewer right into the midst of activity and demands his participation in the experiences he sees before him. The verticals, repeated in a rhythmic pattern find a conflict of interest in the curves of the sunshade, the fruit, and the figures, all of which present a change of pace in size and color.

The grouping of the rectangles and figures provide important space division, and the overlapping figures give depth and dimension. The decisive colors are bold and transparent and impart a quality of energy. The play of warm against cool and light against dark make a happy unity in story, in composition, and in design.

Arizona Beauty

Collection of Republic Financial Corporation,
Dallas, Texas

Despite the fact that the eye is first attracted and held by the strong vertical Sahuara Cacti, there is in this picture a dominance of curves. Note the ovals of the close-up Prickly Pear Cactus, varied in shape, size, and color. Observe the road, the curves of the clumps of grass and weeds, the fluid, transparent arcs of the clouds, and the tops of the Sahuara Cacti. The conflict of the straight strength of the Sahuara makes them stand out quickly, surely and provides the action that holds the viewer's interest.

The negative shapes are particularly important, except for the clouds in which the juicy washes allowed watercolor itself to work its will. Except for the conflicting verticals of the Sahuaras, almost everything was painted as a negative shape. The formations are precise and stimulating with a subtle balance of warm and cool. The shapes of the Prickly Pear were painted behind and left as negative shapes. When everything was completely dry, a pure wash of Winsor Green was flooded into the area, bringing life and transparent color to an important area in the foreground.

Adobe Casa

Collection of Mr. and Mrs. Clifford Owens,
Richardson, Texas

The low horizon creates a feeling of vast expanse of space, the keynote of the Western scene. The fluid, transparent expanse of·the sky, the exciting play of dark and light, hard and soft edges, blending of color, the negative and positive trees are all made more dramatic by the detail in the adobe and figures.

There is a satisfying combination of almost oblique verticals that lend softness but do not arouse unrest, and of slanting horizontals that never quite allow a feeling of a quiet pastoral scene. It is a way of capturing the feeling of the vast space and activity of the West.

The eye cannot take in a picture all at once. Viewing starts where the artist demands attention, at the eye of the picture, attention then travels over each part, bit by bit enjoying the shapes, colors, and values. If the design is good, the eye is forced back to the main area of interest to start the process all over again.

Note the play of warm and cool, dark and light, color variation, contour lines, and shapes that cause the eye to travel from one part to another, across and up and down the picture.

150

Grandaddy's Barn

Collection of Dr. and Mrs. E. A. Siglar,
Dallas, Texas

The L-shaped design pattern, frequently used by the old masters, is found in this picture. Within the main pattern is an intricate arrangement of verticals, horizontals, and obliques, dividing the space into stimulating geometric shapes, no two of them the same size, shape, or color. Many of the shapes are negative and were executed by painting behind with only a bit of texture added. Study their variety in shape, size, space, color, and texture. Note the contour lines. Individual shapes are not standing alone, but are interlocking and grouped. Luminous color is concentrated into the area of greatest interest and not scattered here and there over the scene.

A picture must be built. Each stroke should be the result of thinking and planning. Thought and knowledge must be brought to achieving balanced arrangements of forms in space, pleasing relationships between soft edges and detail, tension or conflict, and variety in shapes, color, value, and rhythm. An artist must build a picture, first in his mind and then on paper. It must not be a hurried process. It begins by making several sketches of the same subject after deciding on the theme and mood. All the elements of design which have been the subject of this book, must be planned and built into the picture, bit by bit. Then should come a process of simplification and elimination of everything that is not pertinent to the total theme. After all the planning, then, and only then, is the artist ready to apply color and water to the paper.

Western Snow

Collection of Mr. and Mrs. Kenneth Boutte,
Plano, Texas

A picture without a point of interest is perplexing, both to the artist and to the viewer. There are many ways to bring the eye to the center of interest and so hold the attention of the viewer: warm against cool, dark against light, simplicity against detail, or with one bright, special pure color. However, the contrast must come with a dramatic bang at the eye of the picture. Here you must have not just dark against light, but the darkest, dark of the whole picture against the lightest light.

In this picture, there is dominance of cool colors and subdued values which are compatible in telling the one story to be presented. There is a dominance in mid-tones with a variety of vertical shapes against which the drama of darks and light play an important role. An important oblique leads the eye into the interest area. The lack of foreground and the placement of the post and gate bring the viewer right into the picture. The large branches break the negative spaces into striking patterns. There are unexpected patches of white against deep contrasting earth tones. The viewer feels the bigness of the trees, the cold of the naked branches, and the twisting and turning of the conflict of nature. At the same time he senses the waiting, resting respite from work.

Cowboy Chuck Time

Collection of Sweetwater Savings and Loan Company,
Sweetwater, Texas

Even before planning the design, the artist should analyze the feeling and the atmosphere of the picture he wants to create. Then he should use everything at his command to bring those feelings to the viewer.

This picture draws the outsider into the midst of the activity. The authentic clothing, paraphernalia, and gear along with the shapes and terrain generate a feeling of nostalgia in the observer. The soft, indefinate, broadly painted and unpainted areas contrast sharply with the fire-lighted detail of the central motif. There is one story and only one, but it is told with innovation.

156

Into the Blue

Collection of Dallas Federal Savings and Loan Association, Dallas, Texas.

Movement is evident in pictures of sailing boats, skiers, and clouds. Where is the movement in a composition of trees? The path dramatically and quickly pulls the eye into the depth of the forest, traveling from a dark warm value in front to a cool light in the interior, with the back road left unpainted to pull the eye immediately into the center of interest. Variety, ranging from light to dark and from misty to sharp definition, creates moving patterns. The weeds bend slightly to show the direction of the breeze. The positive and negative shapes make interesting division of space by the placement of the trunks, limbs, and branches. Always there are receding values, conflict between detail and simple washes, and between hard and soft edges. Yet, all the conflict and variety read as a unity, achieved in part by the all-over cool color and value gradation. Some colors that are cool in themselves appear warm by placement next to a cooler color. The texture on the trees is enhanced by the contrasting, simplified distance.

A Summary of Terminology in this Workbook

Bead is a pool of color that drains toward the bottom of liquid pigment when it is applied to paper.

Cast shadow is the shadow area that occurs when some protrusion cuts off the light source. It may fall on the ground or on some other object, and its shape is controlled by the surface on which it falls.

Contour lines are the imaginary lines that shape and form the ground areas in a picture.

Critique is a critical examination. Critiques in this workbook consist of questions that students learn to ask themselves to help them identify and correct their own mistakes.

Design is the arrangement of the elements of art into a pattern. Designing is deliberate, purposive planning and consists of arranging the elements of art to create a unified, pleasing effect.

Dimension is an illusion in a picture of depth, nearness, and distance.

Elements of art are the simplest, basic building blocks of design. They are the following: color, value, space, shape, form, line, and texture.

Eye of the picture is the place of greatest interest where there is contrast and detail to pull the eye back into the picture.

Form shadow is on the object itself at the points away from the light source and it gives form and depth to the shape.

Interlocking colors result from painting a wet pigment into another wet pigment on paper so some of the colors blend and run to make a third or fourth color.

Jewels are bright colors dropped into wet pigment so they explode and blend and create a variety of colors.

Limited palette is one in which the number of colors used in a single picture is restriced to only a few, some three or five, usually an interesting combination of warms and cools.

Local color is the basic color of an object. If a house is brown, paint it brown all over. Then you can add texture, form, highlights, cast shadow, and other details.

Nuance is the subtle distinction or variation of color and value.

Opaque color refers to thick pigment that does not let the light or underneath color shine through.

Painting behind is painting the positive shape to leave an important negative shape showing, as in painting foliage shapes and leaving branches unpainted so they glisten in the light created by this process. It is painting behind or around an object, not on it.

Perspective refers to representing on a plane the spatial relationship of objects as they appear to the eye, giving a distinctive impression of distance.

Positive and negative shapes depend on whether you paint on a shape or around it. When you paint on a shape, it is positive. When you paint around it or behind it, it is negative. Negative shapes are usually not white because they have been painted by a previous wash.

Rhythm is the flow pattern, movement, or accent in a picture.

Terminology

<u>Roads, rivers, and roofs</u> should be painted last so you will know just how much of them you need to paint. They are horizontals in a picture and often have reflected light, so it usually takes very little painting to make them read.

<u>Thirty percent</u> mixture refers to using water to dilute color to a transparent consistency of about thirty percent of the value of the pigment as found in the tube.

<u>Transparent</u> color means letting the light shine through the color where it is reflected by the white paper underneath. It contributes to the unique beauty of watercolor.

<u>Underpainting</u> is the first step in which liquid pigment is applied, usually to wet paper, to create beautiful colors and soft edges. Shapes and dimension are painted in after the underpainting has dried.

<u>Value</u> is the relative lightness or darkness of a color.

About the artist

Although he operated his own advertising art studio and successfully executed commissions for many of the country's leading companies prior to his death, Bud Biggs' first love was watercolor. Each of his paintings is a culmination of that love affair that spanned more than half a century.

A native of Texas, Mr. Biggs received his education at Southern Methodist University and the St. Louis School of Fine Art. Additionally he studied with many of the world's leading watercolor artists, including John Pike, Edgar Whitney, Bob Landry, Elliott O'Hara, and Milford Zornes. As a workshop instructor, Biggs quickly communicated his enthusiasm for watercolor to his students. His philosophy was to teach grass-roots basics—then develop each student's own individual techniques.

Throughout his lifetime Biggs won numerous honors and awards for his work. His paintings are represented in many permanent collections and galleries.

About the author

Lois Marshall, also a Texas native, is a practicing artist, teacher and writer. Her work has been exhibited in a number of shows including the Southwestern Watercolor Society. She has studied with Zoltan Szabo, Naomi Brotherton, Bud Biggs and others.

As an author Mrs. Marshall's credits include children's stories, magazine articles and a published play. She is a graduate of Baylor University; has a Masters Degree from Texas Tech and has done graduate study at the University of Colorado.